Harold
GILMAN
1876-1919

D0919902

Arts Council
OF GREAT BRITAIN

PREFACE

The 62 paintings and 41 drawings in this exhibition are a substantial proportion of a total output of little more than eighteen years. Harold Gilman's early death in the 'flu epidemic of 1919 cut short a career illustrative, in many ways, of the changes that took place in British painting between 1910 and 1920. One of the Fitzroy Street group, founder member of the Camden Town Group and president of the London Group, Gilman was one of those who believed that new methods are evolved and best disseminated by groups rather than individuals.

Charles Ginner's words, reprinted for the introduction to the catalogue for his joint exhibition with Gilman in 1914, serve not only their original purpose of formulating the aesthetic of 'Neo-Realism', to which both artists subscribed, but also stand to define the direction of Gilman's achievements:

'All great painters by direct intercourse with Nature have extracted from her facts which others have not observed, and interpreted them by methods which are personal and expressive of themselves – this is the great tradition of Realism.'

This exhibition would not have been possible without the generosity of a large number of public and private collectors. We are most grateful to them all. We also join our selectors, Andrew Causey and Richard Thomson of Manchester University, in thanking those acknowledged below and, in our turn, extend our warm thanks to them for their work in selecting the exhibition and writing the catalogue.

Joanna Drew
Director of Art

ACKNOWLEDGEMENT

We would like to make special mention of Julian Agnew, Barbara Duce and the late John Gilman who, in their different ways, contributed information and assistance which has proved invaluable to the realization of this project. We a also particularly grateful to the following people their help: Wendy Baron, Natalie Bevan, Caroli Cuthbert, Anthony d'Offay, Peter Ferriday, Dorothy Gilman, Frederick Gore RA, Andrew Murray, Betty Powell, John Woodeson, and sta the Tate Gallery Archive, the Witt Library, the National Art Library at the Victoria and Albert Museum, Sotheby's and Christie's, as well as th curators and keepers of many public collections home and abroad.

Andrew Causey
Richard Thomson

Abbreviations and Author's Note
The following abbreviations have been used:

AAA	Allied Artists Association
Burl. Mag	Burlington Magazine
Exh:	Exhibited
Indépendants	Salon des Indépendants, Paris
Lit:	Literature
NEAC	New English Art Club
Prov:	Provenance
*	illustrated in black and white
†	illustrated in colour

Book and articles listed in the Bibliography on page 94 have been referred to by author and date with title of magazine or periodical where applicable.

Exhibitions included in the List of Exhibitions o page 36 are identified by date and location.

All other references are given in full.

HAROLD GILMAN: AN ENGLISHMAN AND POST-IMPRESSIONISM

by Andrew Causey

Harold Gilman's short career between leaving the Slade in 1901 and his death in 1919 occurred at a time when serious painters were faced with an unusual number of decisions. Emerging when Whistler had given the mark of his authority to a style of painting that became widely practised – smooth in finish, restricted in colour and closely-graded in tone – Gilman was soon to witness Sickert's challenge to his former master's rule and, shortly after, to see Sickert's own teaching called into question with the new interest in Matisse, Cubism and Futurism. Gilman was an ambitious artist, and the fact that his acceptance of the modern movements was limited to Impressionism and Post-Impressionism was not a denial in principle of more avant-garde trends – he was always a friend and champion of Wyndham Lewis, for instance. It was the reaction of a painter who gave quality precedence over experiment, and who remained to some extent tied to the dominant artistic idiom of the years in which he came to maturity.

After leaving the Slade, Gilman spent a year in Madrid copying Velasquez, whose work was then nearing the end of a long period of high esteem in the minds of artists. The painting Gilman practised until 1909 was one in which greys, greyish browns and blacks were set off against accents of sharper colour, often greens, as in *Portrait of a Lady* (no.4*), *Portrait of Spencer Gore* (no.6) and *In Sickert's House, Neuville* (no.7), but also pinks and, as in *The Nurse* (no.11*), blues. It was indebted to Velasquez and, among modern masters, Manet; in some respects, such as the particularly accomplished use of black against ruddy flesh tone applied with an open brush, Gilman's style recalls Frans Hals. His work had much in common with that of contemporaries like William Orpen, William Nicholson, and Albert Rutherston, and shows that Gilman's ambition was for quality within the framework accepted in a period of interest in the Dutch and Spanish masters.

This essentially Whistlerian idiom was one that had reached the end of its potential development, but Gilman's achievement in it was by no means immature work subsequently eclipsed by a more modern kind of painting. He remained proud of his period of study in Spain, and weighed in with authority on behalf of Velasquez in 1910 when the authenticity of the '*Rokeby*' *Venus* came into question.[1] A legacy of this period was his concern for craftsmanship in painting, and his hatred of the slipshod or incompletely resolved. Gilman's belief in the subordination of drawing to painting, which his friend Charles Ginner stressed in writings about him, was also formed during this early phase; drawing was a means and not an end in itself. Other

painters, particularly those who graduated from the Slade ten years later, during the ascendancy of Roger Fry, learned to value the earlier Italian masters more than the Spanish and Dutch: for them draughtsmanship was more integral with painting, and a draughtsmanly form of modernism, like Vorticism, was possible for them as it was not for Gilman. Gilman's early work was never dead for him; after 1916, as the first wave of modernism passed, the typical subjects of his post-Slade years, the softer colouring and Vermeer-like quietude re-emerge in his work.

Whistler died in 1903 and his memorial exhibition took place in 1905. In that year also Sickert returned from a long period in France 'sent from heaven to finish *all* your educations',[2] as he told one of his pupils, Nan Hudson, and eager to introduce to England 'the genius of painting that still hovers over Paris, and must be wooed on the banks of the Seine'.[3] Gilman had not by then made much impact with his painting, which in a sense was fortunate, as it gave him less to lose than those like Orpen and Nicholson who had established reputations in an idiom that was becoming outmoded. Gilman was also well served by his quiet studious approach, in contrast to contemporaries like Augustus John who adopted Whistler's commanding personal style. A reputation for genius can be restricting, as John discovered; artistic development of the degree Gilman was to undergo would have been impossible for John because of the admission it would have implied of previous imperfection. Whistlerian painting may have been a dead end, but it was hard for those of Whistlerian temperament to escape from it. Lewis was the only artist sharing something of Whistler's imperiousness who became a major force in English modernism, which he achieved only by maintaining a remarkable detachment from English art until the moment for change seemed right.

Gilman met Sickert early in 1907 and became in the spring a founder-member of the Fitzroy Street group, which met on Saturday afternoons under Sickert's informal chairmanship to exhibit and discuss their paintings. Louis Fergusson, a civil servant who became a friend and patron of Gilman, sometimes attended, and remembered Gilman showing 'interiors – women sewing – women taking tea – persons conversing in parlours. The pictures were very intimate very smoothly painted – without impasto',[4] a description which fits Gilman's paintings of 1907–9. Though Sickert's friendship with Gilman developed quickly enough for Sickert to lend the Gilmans his house at Neuville outside Dieppe in the summer of 1907, at this point there was no immediate establishment of a Sickertian circle in England. Original members of the Fitzroy Street group included other tonal painters apart from Gilman, such as Albert Rutherston; after a long absence abroad Sickert needed time to re-establish himself in England, and was reviewing his own painting with the help of Spencer Gore and bringing in more colour. Even at this stage, however, there is an interesting parallel between Sickert and Gilman

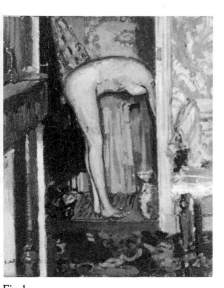

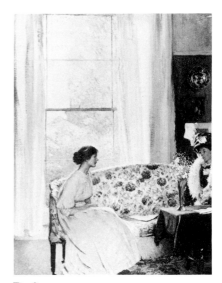

Fig. 1
W. R. Sickert, *Woman Washing Her Hair* 1906
London, Tate Gallery

Fig. 2
G. Clausen, *The Visit* 1909
Private Collection

evident in the framing of figures in doorways in such pictures of
Gilman's as *In Sickert's House, Neuville* (no.7) and *The Kitchen* (no.9†),
which follow Sickert's *Woman Washing her Hair* (fig.1) of 1906.
Painters like Gilman and Orpen had been working in a tradition of
intimiste subject matter independent of that of Bonnard and Vuillard
in France. Indeed Fergusson recalled[5] being surprised when Gilman
started showing at Fitzroy Street to discover that he had never heard
of Vuillard. Sickert was a great admirer of Bonnard and Vuillard, and
surely Gilman's treatment of similar subjects must have been one of
the things that drew Sickert to his work.

In 1905 the Whistler memorial exhibition had caused a greater stir
than the large show of French Impressionists that Durand-Ruel had
put on in London. It was not until Roger Fry's exhibition 'Manet and
the Post-Impressionists' in the autumn of 1910 that artists were
forced to confront late nineteenth-century French painting. Sickert
was to some extent responsible for the change of attitude, not only
through the example of his work, but because from 1908 he began
regularly to undermine his former master's authority in print,
accusing Whistler of being obsessed with taste and dependent for his
effect on a unity achieved by staining the canvas with layers of thin
paint, which Sickert thought worthy only of a watercolourist.[6] At the
same time Spencer Gore, a friend of Gilman since Slade days as well
as a close ally of Sickert, was warning his pupil Doman Turner that
Whistler would lead him only into the backwaters of art.[7] Widespread
denigration of Whistler within the Fitzroy Street group is confirmed
by Sickert's claim, when he returned to the attack at the beginning of

5

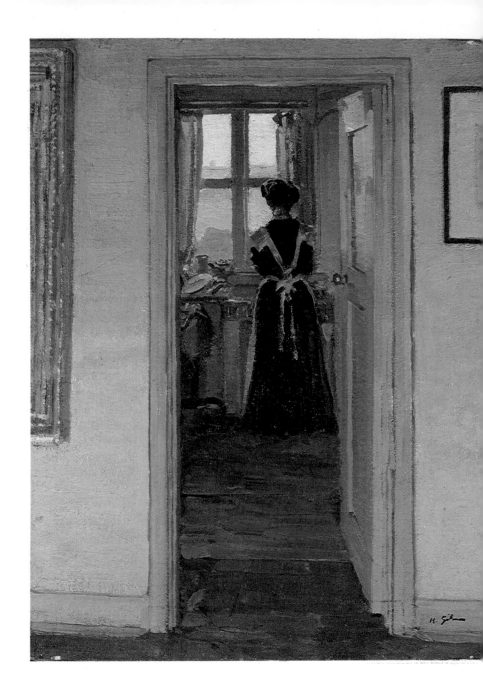

9 *The Kitchen* c.1908

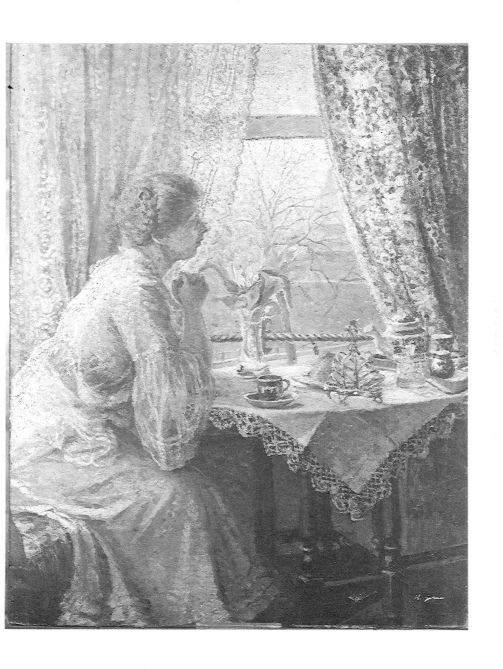

The Breakfast Table 1910

1910, that in explicitly repudiating Whistler he spoke for himself 'and the very solid phalanx of young painters with whom I move'.[8]

Sickert was quite clear about what he believed painting to be, 'a clear and frank juxtaposition of pastes (*pâtes*) considered as opaque rather than transparent'[9], and he was also clear that this was most likely to be found in the New English Art Club, where he saw the characteristic technique as being painting 'with a clear and solid mosaic of thick paint in a light key'.[10] The change evident in Gilman's painting in 1910, in *The Blue Blouse* (no.16*) and *The Breakfast Table* (no.17†) was surely a response, not so much to Sickert's actual painting, as to his advocacy of a substantial paint surface. The colours of the first painting are not very different from those of Gilman's earlier pictures, but the way the colour is used is new; the diaphanous blue used in *The Nurse* (no.11*) is given a new intensity in *The Blue Blouse* and the whole paint surface acquires a different substance. *The Breakfast Table*, with its scattered touches of whitish paint, recalls the older English Impressionists, like Tonks and Steer, whom Gilman knew from his Slade years, and the design and handling of the picture together recall Clausen's *The Visit* (fig.2), one of the major works in his successful exhibition at the Leicester Galleries in 1909.

During the winter 1910–11 the Fitzroy Street group were discussing the formation of a new exhibiting society which was to become, in the summer of 1911, the Camden Town Group. According to Ginner,[11] Gilman became the leading advocate of a complete break with the New English Art Club, which seems at first sight odd, since Gilman's painting was never closer to characteristic New English painting than now and, though often rejected by the Club in the past, Gilman had been hung in 1909 and 1910. The decisive factors for him were 'Manet and the Post-Impressionists', an exhibition which most New English painters reacted to feebly or rejected outright, and a visit which Gilman made shortly afterwards with Ginner to Paris. Ginner had lived and studied in Paris and was able to introduce Gilman to a comprehensive range of Post-Impressionist and more recent pictures in the galleries and collections of Durand-Ruel, Vollard, Pellerin and others. Gilman's insistence on the need for a new society may have been the reaction of an artist who sees ahead the possibilities of dramatic developments which he cannot realize immediately or all at once, and who feels the need for a framework of like-minded artists through which to clarify his ideas.

There is no clear break in Gilman's art in 1911, and no sudden conversion to French painting. In pictures like *Meditation* (no.18*) Sickertian browns are prominent, and the greens and blues with which they are associated are still basically those of the 1907–8 painting although given more substance. In his Romney Marsh landscapes (no.23*) Gilman's design and touch are reminiscent of Steer's early seascapes (fig.3). It was in his nudes (nos.21†, 24*, 25, 26* and 27*), a new subject for Gilman, and one which he seems to have

8

Fig. 3
P. W. Steer, *A Sunlit Sea* 1890
Private Collection

explored at this moment only, that he was at his most adventurous.
They are the paintings of an artist excited at discovering many new
possibilities without having resolved all of them. There are spots and
patches of bright, pure colours, and at the same time the figures tend
to be distinctively drawn and modelled into well-defined planes. 'The
exquisite oneness of surface' – to adopt in description of Gilman's
earlier art a phrase used by Sickert to characterize Whistler's handling
– has gone, and Gilman seems now to be affirming Sickert's conviction
that : 'Mastery is avid of complications, and shows itself in
subordinating, in arranging, in digesting any and every
complication.'[12] In terms of their colour they are transitional,
between Sickertian 'mud', for which, according to Ginner, Gilman
'was already beginning to expound his contempt',[13] and the purer
higher-keyed colour of 1912–13. The *Nude* (no.21†) has a soft
Neo-Impressionist touch which recalls the technique of Spencer Gore
who, according to Fergusson, 'Gilman liked to assert . . . was the
very first English painter to work in pure colours'.[14] Ginner recalled
that through Gilman's 'interest in Lucien Pissarro's work he was
slowly raising colour values',[15] and the general picture that emerges is
of Gilman pursuing – ultimately much further – Sickert's exercises of
a few years earlier in the heightening of colour values. However much
Gilman was struck by his first introduction to French
Post-Impressionism the evidence of his painting is that his first steps

9

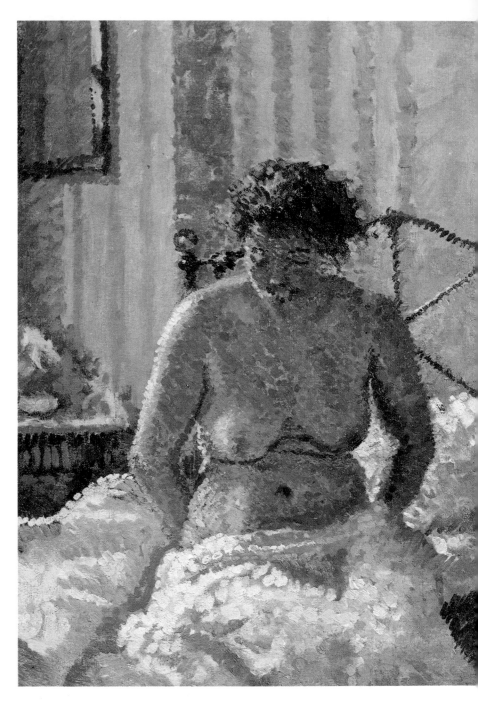

21 *Nude* c.1911

towards a more modern idiom were made with the help of his English contemporaries.

Gilman's progress towards a personal and distinctive form of Post-Impressionism is linked with two changes in his working method which are first evident in 1912. It was then that he began sometimes to make two versions of the same picture by taking off the design from the first, finished painting with a squaring device which was liable to leave a grid effect on the still wet surface. Secondly, the earliest evidence remains from this year of Gilman working from squared-up drawings and colour notes. Ginner describes this as happening about 1911,[16] and it may have been a general mark of Sickert's influence on Camden Town painting then, since Ginner apparently learned the technique from Sickert in Dieppe in 1911,[17] and it is possible that Gilman was there at the same time.[18] Both developments can be associated with Gilman's desire to examine more precisely pictorial, rather than simply visual, problems.

In the summer of 1912, beginning to search for a tighter kind of construction after the diffuse surfaces of the nudes, Gilman seems to have turned first, in *Clarence Gardens* (no.31*) to Cézanne. A comparison between this and the same view also painted in 1912 by his friend William Ratcliffe (Baron 1979, repr. pl.128) shows Gilman less concerned than Ratcliffe with the recording of detail and more rigorous in his search for formal structure. *Clarence Gardens* looks forward to the Gloucestershire paintings of 1916, and there is nothing closely comparable in between. In finding Cézanne a difficult artist to emulate, Gilman shared the experience of many English painters. Neither Fry himself – for all his conviction that Cézanne was the greatest of the moderns – nor the other Bloomsbury painters found Cézanne's finesse of touch easy to imitate.

Gilman visited Sweden in the summer of 1912 and Norway the following summer, with the result that more of his work than previously was of landscape. A problem facing the Post-Impressionist painter who wants to remain close to nature, but also to maintain a unity of pictorial effect, was how to prevent the sky from seeming insubstantial compared with the foreground. Gilman's solution was often to paint the sky in parallel bands of thick pigment which stand forward of the landscape when the two meet at the horizon. It was a technique hinted at in certain earlier pictures, like *Meditation* (no.18*), in which the background round the head appears to have been painted after parts of the head and is sufficiently heavily impastoed to create the momentary illusion that the wall plane is not behind the woman but in front of her. This use of thick impasto to prevent the more distant parts of reality from 'disappearing' in the picture is essentially the same as Van Gogh's, especially in some of the Arles pictures from 1888, and with Van Gogh, too, the effect is sometimes used in the space round portrait heads.

Thick impasto and high-keyed colour mark Gilman's increasing interest in Van Gogh in 1912–13. But his painting from 1912 shows

him rapidly taking command of a whole range of Post-Impressionist techniques. His portraits, like *Sylvia Gosse* (no.47*), have a Matisse-like boldness in the colours and patterns, and in terms of space Gilman is exploring not only landscape, but also shallow space in such paintings as *The Shopping List* (no.36*) and *An Eating House* (no.49*), in which the figures are slotted into the almost abstract areas of colour in a manner reminiscent of Gauguin and the Nabi painters. Some of Gauguin's late paintings, like *The Birth of Christ: Son of God* (1896; Munich, Bayerische Staatsgemäldesammlungen) and *Nevermore* (1897; Courtauld Institute Galleries), are designed, in effect, as a series of flat, decorative colour planes receding parallel to the picture plane: Gilman uses a very similar construction in *An Eating House*. The precursor of Gilman's painting, considering its subject and style together, is not Van Gogh's *Night Café* (1888), with its fully described deep space, but the much flatter painting Gauguin made at the same time, *Night Café at Arles: Madame Ginoux* (Moscow, Museum of Western Art).

Gilman's reactions to the Post-Impressionists were recorded by his friends Ginner and Frank Rutter, the art critic of the *Sunday Times*, who was in Paris with Gilman and Ginner when they were looking at the major collections. Both recalled[19] that Gilman's first enthusiasm was for Gauguin, that this was soon supplanted by a passion for Van Gogh, and that ultimately he came to value Gauguin least of the great trio of Post-Impressionists, below Cézanne. Lewis also remembered his overriding passion for Van Gogh, his delight in finding one of his own pictures good enough to hang next to a Van Gogh postcard, and his keeping a volume of Van Gogh's letters in his room.[20] The devotion to Van Gogh was lasting, and is especially clear in Gilman's remarkable late reed pen and ink drawings. But Gilman's particular attachment to Van Gogh may not have been entirely connected with his art. Rutter recalled that 'roughly handled by life, Gilman began to think for himself and take little or nothing on trust. In politics he became a Socialist with a profound dread and mistrust of society. . . Van Gogh particularly appealed to him, partly because Gilman himself had a good deal of the Dutchman's profound humanitarianism.'[21] In a sense Gilman had been 'roughly handled' in that his education had been severely interrupted by an accident which left him with a permanent deformity to his hip; he had made an unfortunate marriage to a wife whose family were hostile to his profession, and when she left him in 1909 he lost sight of their three children of whom he was extremely fond; his family, and he himself after the departure of his wife, were very hard up, by contrast to several of his artist friends who were supported by outside sources of income. Rutter's statement may well be somewhat exaggerated, and certainly Gilman was not an outsider as Van Gogh was. But he did take from the French Post-Impressionists an image of the artist being beyond ordinary society, to the extent that in 1912 he seriously proposed to Camden Town colleagues that they should go and live in

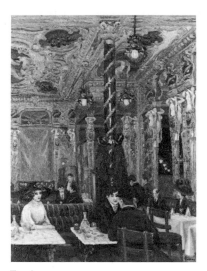

Fig. 4
C. Ginner, *The Café Royal* 1911
London, Tate Gallery

the South Seas and Arthur Clifton of the Carfax Gallery should be their agent in London.[22]

In 1914 there was a change in Gilman's work which marked the influence of Sickert giving way in part to that of Ginner. His colour became more sombre, deep greens, greenish blues and dark purple-brown replacing the brighter colours of 1912–13. Paint was sometimes used more decoratively and flatly, with areas of colour modulated only by the pattern of overlapping brushstrokes. Gilman's friendship with Ginner had been growing since 1910, and doubtless Ginner, who had used heavy impasto since before he settled in London in that year, had encouraged Gilman in his admiration for Van Gogh. Unlike Sickert, Ginner cultivated quality of surface rather than plasticity of form, and seems to have been drawn to painters like the still very influential late nineteenth-century Italian Segantini, whose colour was rich and intense and the pattern of whose brushmarks plays a distinctive part in forming the character of his painting.

There is no question of Gilman's having come rapidly under Ginner's spell, any more than he had been quick to give himself to Sickert. For example, the ancestry of Gilman's *Café Royal* (no.30*) of 1912, with space and light skilfully suggested by subtle abstractions from reality, is in Sickert's paintings of interiors, notably those of St Mark's. Gilman's painting is oddly unlike Ginner's *Café Royal* (fig.4), done the previous year, in which the handling of paint is draughtsmanly, facial features are drawn out, and trails of thick paint follow the shapes of the architectural stucco with descriptive precision.

13

But by 1914 Gilman's painting was becoming more decorative and less concerned with the building up of form in the Sickertian sense. In the parallel tracks of paint on the dress of *Mrs Victor Sly* (no.53*), for instance, and in the block-like handling of the paint on the door behind her, interest is created by the shapes and colours of the marks themselves and not by any effect of space or light that they make. The slightly later *Portrait of a Lady* (no.67*) is more linear, and though Ginner was not primarily a portraitist, it is in his paintings of figures, like *La Vieille Balayeuse, Dieppe* (1913; Private Collection), that the source of Gilman's new direction can at least in part be found.

The Gilman-Ginner alliance was cemented by their exhibiting as Neo-Realists, first at the Allied Artists Association in the summer of 1913, and again at the Goupil Salon in the autumn. In April 1914 they shared an exhibition at the Goupil Gallery, for which Ginner's manifesto, 'Neo-Realism', published in *The New Age* on 1 January, served as a catalogue introduction. Neo-Realism can be seen as part of the trend for the rival modernist groups to issue their own manifestoes which was to lead to Lewis's *Blast*, Nevinson's 'Vital English Art. Futurist Manifesto', and – of a rather different character – Clive Bell's *Art*, all of which were published in 1914. Also in that year the Neo-Realists planned publication of a periodical, that was postponed by the outbreak of war and finally emerged in 1917 as *Art and Letters* under the editorship – at first – of Gilman, Ginner and Rutter.

At the core of Neo-Realism was the idea that good art is the product of constantly renewed contact with nature, as in the work of the Impressionists and the three Post-Impressionists, Cézanne, Van Gogh and Gauguin. Gilman had proposed a not dissimilar idea four years earlier in his article 'Composition in Painting',[23] in which he had said: 'Life dictates the shapes, the artist only holds them. If forms don't please, look for another motive. Nothing but life can imitate the real.' In 'Neo-Realism', however, Ginner went on to say that in the hands of Matisse and the Cubists art had become debased because this immediate contact with reality was lost. Gilman was not drawn to Cubism personally, and in his heart perhaps agreed with Ginner. At the same time he was genuinely in favour of experiment, and advocated the unity of the avant-garde through the London Group, of which he had recently been elected president. In an interview with the *Standard* on 3 February 1914, he conciliated between Ginner and the admirers of Matisse and Cubism by acknowledging the difference between 'Realist' and 'Formula' art, but inferring that they were both valid, alternative approaches.

'Neo-Realism' drew an aggressive riposte from Sickert,[24] not because he deeply disagreed with it, as he admitted, but probably because he resented the pontifical tone of what was certainly a statement of modest substance. Sickert attacked Gilman and Ginner again in his review in the *New Age* of the spring exhibition of the New English Art Club,[25] deploring the artists' increasingly heavy impasto, which he saw as unrelated to any definition of form. Gilman

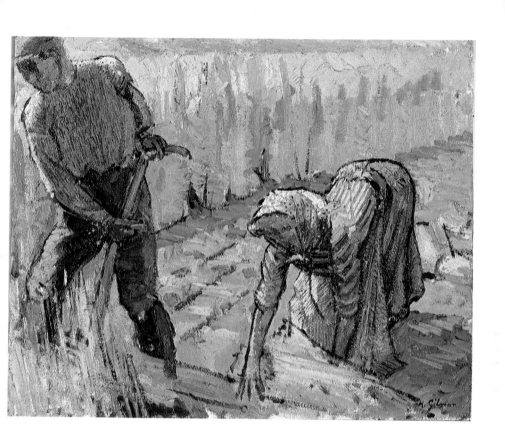

The Reapers, Sweden 1912

was showing *The Coral Necklace* (no.50*), in which the weight of pair and what Sickert called 'the seething edges' of the powerful brushmarks brought Gilman close to artistic anarchy in some areas of the canvas. Gilman had used comparably bold strokes in *Girl Combing her Hair* (no.27*), but there the colour relationships made the spatial structure of the painting crystal clear, while here, with little colour variation in some places, the shape of the brushmarks themselves was scarcely adequate to sustain a sense of form. Gilman's increasing use of contour and drawing in 1915–16 was in part a way out of this impasse it enabled him to define forms without necessarily resorting to colour variation. There was an element of paradox in this solution since his earlier dislike of contour had led him to exhibit a portrait of his mother (possibly the one now in the Tate Gallery) at the Allied Artists in 1912 as *Thou Shalt not Put a Blue Line round thy Mother*.

The breach with Sickert became a permanent rift the following autumn when Sickert reclaimed a teaching post at the Westminster Institute which Gilman had been filling, and though Sickert wrote a complimentary review of Gilman's contribution to the autumn 1915 exhibition of the London Group, their friendship was not renewed. It was a quarrel which needs to be seen in its fullest context: the meeting which set up the London Group in November 1913, formally uniting Camden Town with the future Vorticists, was chaired by Sickert and occurred at 19 Fitzroy Street, the place which for over six years had symbolized Sickert's leadership. Though Gilman was elected president, it was Sickert who took the chair at the first meetings, as he had those of the Camden Town Group under Gore's presidency. Already uncomfortable at the pressure from Gilman and Gore to include Lewis in the Camden Town Group, and now forced by them to accept Epstein whose work, like Lewis's, he did not care for, Sickert resigned at the beginning of 1914. His loss of influence in general must have been one cause of disputes with Gilman. But his criticism of Gilman was quite genuine: when he returned from Dieppe he had himself faced the problem of maintaining a sense of form with thick paint and sometimes slight colour differentiation; it must have been saddening to see a painter as close to him as Gilman creating a similar problem for himself. Sickert had been working with thinner paint since about 1912 and had now just completed *Ennui* (1913–14; Tate Gallery), on a larger scale using thinner paint and with a more clearly defined space than in his previous work. Ginner recalled[26] that Gilman never ceased to admire Sickert's work, and it is interesting to note how in 1916 Gilman shifted his direction, in *Tea in the Bedsitter* (no.74*), to a larger canvas, with deeper, more defined space, and a more controlled handling of paint.

Ginner remained Gilman's closest artist friend until Gilman's death, but his limitations as a painter were obvious, and Gilman's art from 1916 is the outcome of a search for a new kind of Post-Impressionism, more controlled, austere and highly finished

than Sickert's work, but more sophisticated in formal terms than Ginner's. After the resignation of Sickert from the London Group and the tragic death of Gore in March 1914, the core of former Camden Town members survived in the Cumberland Market Group, in which Robert Bevan played a leading role. The jagged edges with which Bevan was beginning to surround his forms picked up ideas that Gore had been investigating in his 1912 Letchworth paintings and probably have their origin in the early Cubist work of Derain. This style emerged briefly in Gilman's painting, in *The Lane* (no.55*). But the idea was not pursued, a mark of Gilman's reluctance to conceptualize his forms beyond a point where his dependence on nature was immediately evident. Cubism was no use to Gilman because it did not refer back constantly enough to visual reality. But the trend of Gilman's thought is obvious from the way *The Lane* leads on to the Gloucestershire beechwood paintings of 1916 (nos.66 & 71*). These are forcefully structured canvases, worked in a limited range of colours, and each individually observed without trace of formula; Cézanne's example here served Gilman in a way that Cubism could not.

In this later phase of Gilman's Post-Impressionism, as in the earlier, the influence of one artist is not easy to distinguish from that of another. Mrs Mounter's orange headscarf (no.76†) seems to be quoted from the orange hair of Christ in Gauguin's *Christ in the Garden of Olives* (1889; Norton Simon Foundation), which was shown at 'Manet and the Post-Impressionists', and the deep rich colours of Gauguin's Tahitian period and his love of contour are evident in Gilman's painting especially around 1915–16. Gilman's *Interior with the Artist's Mother* (no.88*) uses strokes of dark brown and dark green very much as Van Gogh used them in the cypress tree in *Starry Night* (1889; New York, Museum of Modern Art). The most important development in Gilman's later Post-Impressionism is a more mature understanding of Cézanne. The dependence on drawing in *Portrait of a Lady* (no.67*) disappears, but in reverting to a more painterly solution Gilman avoids the exuberance of earlier portraits like *Sylvia Gosse* (no.47*), and constructs his forms in firmer, broader planes, which give his late figures something of the character of Cézanne's portraits of the 1880s. In his landscapes, too there is a more Cézannesque approach, as in the foreground of the *Halifax Harbour* commission, where blocks of colour are built up constructively, with an almost sculptural force.

Detailing Gilman's debts to individual painters does not quite define his deep sympathy with the Post-Impressionists. In his portraits especially, and *Mrs Mounter* (nos.68*, 69, 75*, 76†) above all, he engaged in that sensitive but direct confrontation of artist and sitter of which Van Gogh in particular, but Cézanne and Gauguin also, were masters: a confrontation that dignifies without flattering and is not limited by any class condescension.

The paintings of Gilman's last three years are his most assured works, directly presented and yet often elaborate in composition,

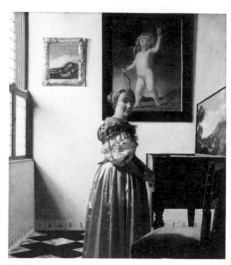

Fig. 5
J. Vermeer, *A Young Woman Standing at a Virginal* c.1670
London, National Gallery

highly finished without being bland. They look back in subject to the figures in interiors of his early tonal paintings, and recover something of the even surfaces and cool colouring of these works. As the modern movement in England lost momentum on account of the war and the Vorticists began to drop out of London Group exhibitions, from the autumn of 1915 critics began to pay more attention to former Camden Town members' work. Phrases emerge in reviews such as 'aesthetic Puritanism',[27] which defines Gilman's drier and more precise handling, his gradually increasing use of greys and pastel colours, and his willingness to leave substantial unpatterned areas in place of the busy wallpapers that dominate his interiors to 1916. There is an abstract character to the spaces and the intervals between objects in late paintings like *Interior with the Artist's Mother* (no.88*), which was perhaps affected by the near-abstract and in some instances completely non-figurative paintings of the Bloomsbury artists, Vanessa Bell and Duncan Grant, in 1914–15. But Gilman's painting was as much as ever about people and their activities, the way they occupy rooms and share spaces with inanimate objects, and in this respect his work is close to that of the seventeenth-century Dutch painters like Vermeer and de Hoogh. Vermeer's reputation was growing steadily at that time, and the two paintings by which he is now represented in the National Gallery (fig.5) were then both fairly recent acquisitions. There is a sense of peace and solitude in Gilman's late interiors that contradicts the horror of the years in which they were painted, as the measured calmness of Vermeer's interiors was unswayed by the crises of seventeenth-century Holland.

Notes

'The Venus of Velasquez', *Art News*, 28 April 1910.

Quoted in Baron, *Sickert*, 1973, p.105.

'The New Life of Whistler', *Fortnightly Review*, December 1908.

Lewis and Fergusson, 1919, p.19; Hubert Wellington, another painter who occasionally came to Fitzroy Street, confirmed Fergusson's description, in his introduction to 'Hubert Wellington: A Retrospective', Agnew, 1963.

'Souvenir of Camden Town...', *Studio*, February 1930.

'The New Life of Whistler', op. cit.

Letter from Gore to Turner, 8 October 1908, quoted in Rothenstein, *Modern English Painters*, vol.1, 1952, p.199.

'Abjuro', *Art News*, 3 February 1910.

'The New Life of Whistler', op. cit.

'The New English and after', *New Age*, 2 June 1910.

'The Camden Town Group', *Studio*, November 1945.

'Where Paul and I differ', *Art News*, 10 February, 1910.

'The Camden Town Group', op. cit.

Lewis and Fergusson, 1919, p.28.

'Harold Gilman: An Appreciation', *Art and Letters*, Spring 1919.

'Harold Gilman: An Appreciation', op. cit.

See Rothenstein, *Modern English Painters*, op. cit. p.193.

There are Dieppe paintings by Gilman dateable to 1911. The Dieppe trip could have coincided with the Paris visit he made with Ginner.

19 Rutter, *Some Contemporary Artists*, p.122, and Ginner, 'The Camden Town Group', op. cit.

20 Lewis and Fergusson, 1919, pp.12–13.

21 Rutter, 'The Work of Harold Gilman...', *Studio*, March 1931.

22 Information from Frederick Gore RA, whose father, Spencer Gore, dissuaded Gilman.

23 *Art News*, 25 May 1910.

24 *New Age*, 30 April 1914.

25 *New Age*, 4 June 1914.

26 'Harold Gilman: An Appreciation', op. cit.

27 Headline of review of London Group exhibition, *The Times*, 10 November 1917.

GILMAN'S SUBJECTS:
SOME OBSERVATIONS

by Richard Thomson

At first glance the subjects Gilman treated seem to hold no surprises. Portraits, landscapes, nudes, interiors, some urban pictures – cityscapes or café scenes – and still-lives; this was the standard range of many painters around the turn of the century. Yet Harold Gilman added some very personal nuances to the conventions of those subjects. The period which encapsulated Gilman's career, from the late 1890s to the end of the First World War, were years which saw the hey-day of the New English Art Club and later the assimilation of 'Post-Impressionist' influences from France. They were also years of great change and social unrest in Britain. Both these elements need to be borne in mind when we consider Gilman's subject-matter; when we discuss the paintings of Mrs. Mounter, for example, it may well be as necessary to mention the disturbing effect of the Great War on the British population as to discuss the influence of Cézanne.

Throughout his career Gilman was a consistent painter of portraits. His early portraits, up to about 1908, tend to rely on the models esteemed by young English artists, particularly Velasquez and Whistler. Ginner recorded that his 'works of this period... consisted most of them, of full-length portraits, some life-size, and generally on a large scale'.[1] Little remains in the way of portraiture, but from the available evidence – the copying in the Prado, Ginner's recollections and *The Negro Gardener* (no.5*) – the impact of Velasquez is clear. We can detect in *The Negro Gardener* the characteristics of this prototype: a natural but barely descriptive setting, a normal but undemonstrative pose, and a sympathetic grasp of the sitter's being at its most still and sober. Nor was Gilman unaffected by Whistler's recent reappraisal of this tradition of portraiture. The pose of that contemporary talisman, *Portrait of the Artist's Mother* (1871; Paris, Louvre), was 'acknowledged a classic'.[2] It made its presence felt in portraits as different as Orpen's *Augustus John* (1900; Tate Gallery) and Gilman *Portrait of a Lady* (no.4*) of about 1905. In this painting, with his scrupulous record of nervous fingers and rather angry features that seem scarcely able to mask a bitter frame of mind, Gilman gave early evidence of his talent for revealing a personality. He rarely let slacken his ability to isolate and transcribe the mood of his model – he was particularly sensitive to women and preferred them as sitters – and from an early stage showed his penchant and sympathy for withdrawn expressions of melancholy and vulnerability. *Portrait of a Lady* also established a number of other features that were to persist in Gilman portraits. Gesture, for example, he preferred to keep to an undemonstrative minimum. Nevertheless, he recognised the character of hands and rarely left them out.

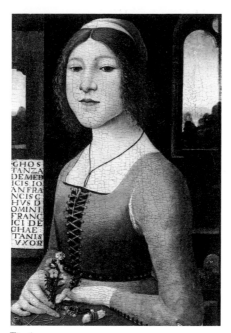

Fig. 6
D. Ghirlandaio (Style of), *Costanza Caetani*
c.1489–1507
London, National Gallery

Between about 1910 and 1914 Gilman made the most attempts to develop the range of possibilities for his portraiture. His use of pose is of particular interest. *The Blue Blouse* (no.16*) of 1910, for example, shows that Gilman was keeping abreast with a pose common in the NEAC, the forceful frontality for the half-length female portrait recently essayed by Orpen, in *Lottie of Paradise Walk* (1905; Leeds City Art Gallery), and William Nicholson, in *The Girl with the Tattered Glove* (1909; Cambridge, Fitzwilliam Museum). Gilman's increasing interest in modern French painting during these years also affected his portraiture. He owned an album of fifteen black-and-white reproductions of paintings by Cézanne, published in 1912[3]; one of these photographs was of a canvas of the early 1890s, *Mme Cézanne in a Yellow Armchair* (Chicago, Art Institute). This painting embodies Cézanne's favourite pose for his wife, seated and seen more-or-less frontally, with her hands joined on her lap. Gilman and Gore both adopted this pose for portraits made in 1913, respectively *Sylvia Gosse* (no.47*) and *The Artist's Wife* (F. Gore and E. Cowie Collection). Gilman's picture also suggests a challenge to his own skill as a portrait painter, for such an emphatically frontal pose implies a confident sitter, whereas Miss Gosse was extremely shy.[4] Gilman had other resources than modern French painting as he developed his portraiture. His favourite picture in the National Gallery was a

21

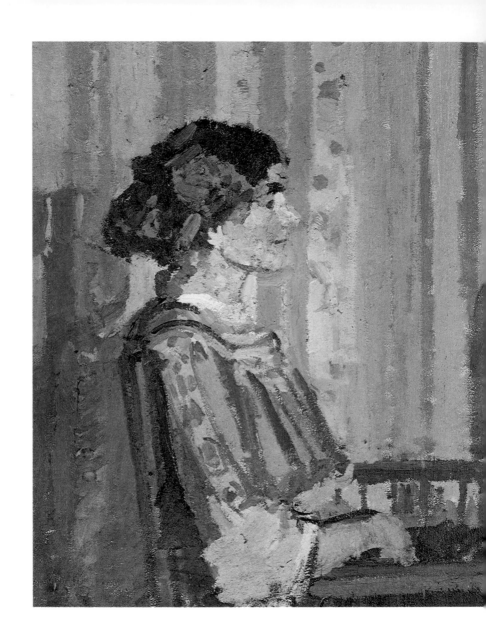

45 *Mrs Robert Bevan* c.1913

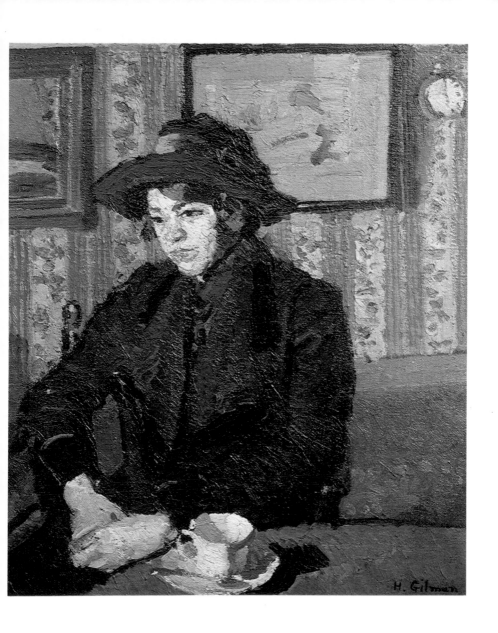

Girl with a Teacup c.1914

Quattrocento portrait (fig.6), now loosely labelled 'style of Ghirlandaio'.[5] In this painting the figure is slotted into space, the curves of the torso locked into an almost diagrammatic design, with a likelihood and dignity of pose that surely relates to portraits such as *Ruth Doggett* (no.63*). If these poses tended to the regimented Gilman did explore, around 1914, a more relaxed scheme for seated figures, viewing the sitter from above and on a diagonal, as in *Mrs Victor Sly* (no.53*) or *The Coral Necklace* (no.50*). After these few years of experimentation Gilman began to revert to the repertoire of poses of his earlier years, and the late painting of his mother reading (no.88) is a reprise of the Whistlerian formula.

With a group of canvases made between 1905 and 1908 Gilman established his credentials as a painter of domestic interiors. Although equivalent subjects and even treatment can be found in contemporary French art – *The Kitchen* (no.9†), for example, reminds one of the recent work of Félix Vallotton – we have too little information about Gilman's knowledge of continental developments at this stage of his career to make specific parallels and, after all, the realistic depiction of middle-class households in sober tones was a commonplace in European painting of the period. We do know that Gilman admired seventeenth-century Dutch art.[6] In de Hoogh's *Courtyard of a House in Delft* (fig.7), for instance, there is a balance between foreground and rear space, and a depiction of different activities in each space, which is shared with, say, *In Sickert' House, Neuville* of 1907 (no.7). A slightly earlier interior, *The Nursery, Snargate* (c.1905–6; Fox Fine Art), includes in the background one of Gilman's copies after Velasquez,[7] and the general disposition of *The Nursery* has a faint echo of *Las Meninas*. Gilman's sense of space in these early interiors is often reminiscent of seventeenth-century art, and he must have read Stevenson on Velasquez: 'The rule was and still is that every space must co-operate in the effect, but not necessarily by lines, agitated colours, and defined forms'.[8]

In the first decade of this century there was much discussion of what we might broadly call the genre scene. The Victorian anecdotal subject had fallen from favour and yet interior scenes with figures were noted to be of increasing interest among the painters of the New English Art Club.[9] A number of these artists, including McEvoy and William Rothenstein, shared a concern for a certain kind of subtle narrative subject. Such scenes did not necessarily have an overt story, but a core of human interest which can be explained in terms of a likely, normal occurrence or emotion. This addition of a quasi-literary element by allusion was defined by a reviewer of the NEAC exhibition in June 1907: 'The best work is not understood at a glance it is subtle and elusive, or whatever may be their equivalents in art circles . . .'.[10] Parallels were even drawn with Victorian art, for example by the critic of the *Studio* discussing Rothenstein's *In the Morning Room* (fig.8) in 1909: 'Mr William Rothenstein places his

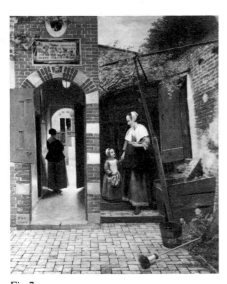

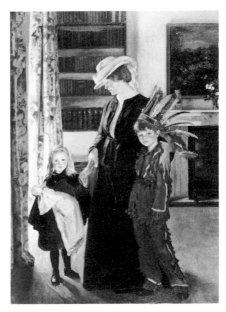

Fig. 7
P. de Hoogh, *The Courtyard of a House in Delft*
1658 London, National Gallery

Fig. 8
W. Rothenstein, *In the Morning Room* c.1909
Manchester City Art Galleries

family group in a modern sitting-room which seems to suggest a little of the ultra-modern affection for Victorian associations. It is part of his exquisite art in details that, among the things above the mantelshelf, the framed picture should, for a moment, awaken interest in itself only to evade us as a mere suggestion of colour admirably tuned to the vase of flowers against it. The whole painting is, for the observant, made up of transitions from one subtlety to another'.[11] If paintings like Rothenstein's were recommended to be read with attention to nuances of psychology as well as style, how should we read another family scene, Gilman's *Interior* (no.8*)? The foreground is dominated by the nanny and child, looking at a book or suchlike, while in the background, her head turned away from us as she stokes the grate, is the child's mother. The painting may be an observation of the realities of the Edwardian class structure, in which the parents amuse themselves while the servants cope with the children. It may even be a remark on the painter's part about the state of a precarious marriage, as his wife tends the fire and he, in his own way, watches the child. But this painting clearly alludes to different centres of emotion and interest, exploring the details of lives lived within small confines, and here Gilman subscribed to the subtle conventions of implicit narrative current in the contemporary work of Rothenstein, McEvoy, Orpen and others.

 After 1910 and *The Breakfast Table* (no.17†) Gilman's interiors dealt, for a period, with subjects other than the domestic scene, either

coming to terms with the urban world, as in *An Eating House* of 1913–14 (no.49*), or almost taking on the quality of a portrait, which is the case with *The Old Lady* of about 1911 (no.19). In 1916, however, he returned to interiors with narrative allusions. *Tea in the Bed-sitter* (no.74*), painted in that year, certainly has narrative elements. When we ask who these two disconsolate young women are, seated at a table laid for four in a sparsely furnished bed-sitter, we find no direct answer. The implicit but unexplained use of 'story' in *Tea in the Bed-sitter* was similar to Sickert's recent experiments, which Gilman would no doubt have known; in Sickert's ambiguous etching *A Little Cheque* (1915) the figures were 'played' by two friends of Gilman, Ginner and his reputed mistress Mrs Sly (see no.53*). But, as we have noted, Gilman's earlier interiors had sometimes explored the ambiguity of human relationships and he was in no necessary debt to Sickert. In other late interiors Gilman painted purely personal scenes, celebrating his new wife and their baby; *Sylvia Darning* of 1917 (no.87*) set the tone for a number of gentle, private paintings.

Gilman's close association with Sickert, Gore and the other Camden Town painters led to a period, between about 1910 and 1914, of considerable experiment, as we have seen. In terms of subject his greater involvement with the London artistic scene led him to attempt more urban themes than before. But of all the central Camden Town Group artists, except the dedicated landscape painters Pissarro and Manson, it was perhaps Gilman who was least at home with the subject-matter of the city. The appetite for entertainment themes common to Sickert and Gore was not shared by Gilman, an artist who was always happiest with a static image. His cityscapes avoided the hard surfaces and continual movement of the urban world and in canvases such as *Clarence Gardens* (no.31*) he preoccupied himself with the landscape painter's problems that found resolution in the *Beechwood* paintings of 1916 (no.71*); Gilman was unwilling to adapt his interests to the demands of the city subject. His choice of urban motif was, for a Camden Town painter, inconsistent, even hesitant. Whereas others tended to tackle regular themes – Gore the cityscape and music-hall, Ginner the street scene, Bevan the cab-yard and horse-sale – Gilman's selection was less programmatic. He painted a variety of subjects, from squares and shop-fronts to the Café Royal (nos.32*, 30*), but specialized in none. Gilman's inclinations are most apparent in a close comparison with his contemporaries. When Ginner and Orpen chose to paint the Café Royal they approached the subject via appropriate conventions. Ginner's canvas (fig.4) is anecdotal, showing two men conferring about the lone woman at the next table, while Orpen's (1912; Paris, Palais de Tokyo) is ordered as an eighteenth-century conversation piece. Gilman's *Café Royal* (no.30*), also made in 1912, neglected the details of décor and clientele for the matter of painting, marking shapes and tallying colours; Gilman was always a painter, not an annalist. But when deeply pondered pictorial concerns were combined with a suitable subject he

London Street Scene in Snow 1917–18

was at his best. Perhaps the most salient example of this is *An Eating House* (no.49*), which continued the earlier preoccupation with siting figures in precise interior space and produced a potent image of urban alienation.

Gilman's choice of subject-matter – and the nature of this choice is at its most apparent in the years immediately preceding 1914 – is notable for its orthodoxy, for its implicit suspicion of the modern. Spencer Gore, by comparison, was prepared to flirt with modern concepts: witness his participation in the Golden Calf Cabaret decoration, the Omega Workshop project, and images such as *Flying at Hendon* (1912; Private Collection). Gilman accompanied Gore on the trip to Hendon, and they both went up in an aeroplane, but Gilman did not record the event in paint.[12] On his trips to Scandinavia in 1912 and 1913 Gilman concentrated on picturesque rural motifs. *The Reapers, Sweden* (no.35†) is both a depiction of old-fashioned harvesting methods and a quotation from Van Gogh's *Memory of the Garden at Etten* (1888; Leningrad, Hermitage), while *The Canal Bridge, Flekkefjord* (no.41) represents an antiquated bridge and must refer to the many paintings of drawbridges made by Van Gogh in Arles.[13] Such a self conscious choice of rural motifs not only reflects Gilman's wariness of the modern subject, but also his increasing inclination to match his own art against Van Gogh's. His ambivalent attitude to modernity emerges nowhere more clearly than in his response to Letchworth. He was prepared to buy a house in the new Garden City, but never seems to have depicted it, a task he left to Gore. A striking instance of the innate conservatism of Gilman's imagery is the contrast between the paintings he made in Sweden in 1912 and the canvases Gore painted while staying in Gilman's Letchworth house at the same time. While Gilman painted the harvester and his traditional scythe Gore took the spanking new suburban station as a subject (Anthony d'Offay).

As early as 1911 a critic suggested that the paintings of female nudes produced by the Camden Town circle had a common formula for treating the subject. Huntly Carter, writing of Gore, complained that: 'In his realistically dreary interiors, in his ugly and distorted nudes sprawling on beds, stepping in and out of baths, and elsewhere posing at toilette, Mr Gore manifests the mannerisms of a school'.[14] Carter must have based his definition of this approach to the nude on the paintings of Sickert and Gore. In the paintings he made between about 1911 and 1913 Gilman evinced a different attitude to the nude, despite superficial similarities to his Camden Town colleagues.

Sickert's earlier images of nudes, those painted in Venice in 1903–4 or in Paris in the autumn of 1906 for instance, tend only to show a single figure, whereas the paintings produced around 1908–9, including the so-called *Camden Town Murder* group, show pairs of figures, linked by some indefinite but insistent narrative element. Gilman, in responding to the possibilities proffered by the older painter, only tackled the former type, but despite the shared setting of

ramshackle room, iron bed and grubby sheets, his single nudes differ
markedly from Sickert's. In canvases such as *The Beribboned
Washstand* (1903–4; Private Collection) or *La Hollandaise* (c.1906;
Private Collection) Sickert concentrated on technical concerns, on
contre-jour and foreshortening; the models have no personality, their
faces are an anonymous assembly of painted marks. Gilman tried very
hard to dispel the aura of the studio. He invested his nudes with
characters and responses. The early *Nude* (no.21†), for instance, is a
delicate study of bashfulness and vulnerability, as she shows her body
but averts her gaze; it is a painting of a woman, not a model. Whereas
with Sickert's nudes we are onlookers, we are participants in the lives
of Gilman's.

It is important to remember that sex was a topic of public and
controversial debate at the time when these canvases were painted.
'The conflict between. . . two opposing ideas of sex – the repressing
and the liberating – continued throughout the Edwardian period,
increasing in intensity as the Edwardian sexual revolution advanced'.[15]
An issue of considerable controversy was female sexuality. As Marie
Stopes wrote in 1918: 'By the majority of "nice" people woman is
supposed to have no spontaneous sex-impulses. . . So widespread is
the view that it is only depraved women who have such feelings
(especially before marriage) that most women would rather die than
own up that they *do* at times feel a physical yearning indescribable,
but as profound as hunger for food'.[16] Gilman's nudes deal with
female sexuality. Two paintings in particular, in York and the
Whitworth Art Gallery (nos.24*, 25), depict a mood of unabashed
sexual enthusiasm. This is particularly true of the York painting,
where we – and the artist – are face to face with the naked woman, and
she smiles back.

The frank sexuality of Gilman's nudes may not be the limit to their
intended effect. Again, contrast with Sickert is constructive. The
linked figures of his *Camden Town Murder* group do not illustrate an
actual event, but they do function as a drama performed in front of
the viewer. Sickert gives us a narrow range of narrative possibility and
stimulates speculation about the specific roles his figures play,
providing no solution. It is the very ambiguity of the scene that
sustains the mood of the picture, extends in time the image's effect.
Gilman never adopted these methods of Sickert's for giving his nude
subjects something of the status of genre scenes. But this is not to say
that Gilman's nudes are devoid of narrative meaning. At the
exhibition he shared with Gore at the Carfax Gallery in 1913 Gilman
gave his four paintings of nudes the simple labels 'Nude (No.1)' or
'Nude (No.4)'. This may merely have been a rather stark way of
noting the order in which they were painted. But the implicit sequence
could have signified more than this. Three canvases clearly painted
at much the same time – *The Model. Reclining Nude* (no.26*), *Nude
Seated on a Bed* (no.25), and *Nude on a Bed* (fig.9) – appear to show
the same woman and the same bed, thrust diagonally against the same

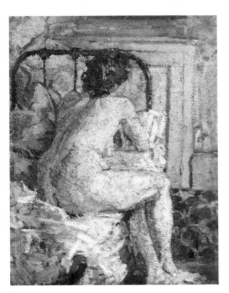

Fig. 9
Nude on a Bed 1911–12
Cambridge, Fitzwilliam Museum

Fig. 10
P. Cézanne, *Femme à la Cafetière* c.1890–95
Paris, Louvre

wall. It would obviously be going too far to argue that these images represent three different incidents in the same narrative. But, given that Gilman places the spectator in a direct relationship to the nude, it could be that each image evokes a specific kind of contact and a specific response from the naked woman. The Fitzwilliam *Nude* thus presents us with a shy woman or one who has been offended, perhaps, while *The Model* conjures up a mood of accustomed languorousness. Such a grouping, investigating different, even antithetical, emotions and with the suggestion of a sequential quality, was almost certainly informal, probably unconscious, but Gilman was by no means alone among his contemporaries in such experiments. Orpen, for example, painted in 1906 a nude lying on her belly, head on hand, and with a pensive expression on her face (Leeds City Art Gallery). Four years later he depicted the identical pose, but changed the mood of the painting by the merest alteration, making the model look alertly at the spectator (Tokyo, Gallery of Western Art).

One undercurrent in Gilman's work that can also be traced in his Camden Town colleagues and other contemporaries can only be described as 'Britishness'. Gilman was ranked by Ginner with 'Hogarth, Rowlandson and the great English tradition of realism', while to Wyndham Lewis he embodied 'every virtue of middle-class England'.[17] The years before, and of course during, the First World War were intensely nationalistic, and the character of many artists' work was informed by a certain chauvinism. It may well be possible to see a number of Camden Town paintings aiming at the creation of a

peculiarly 'British' still-life; one thinks of Bevan's *Whisky and Soda* (1914; Anthony d'Offay) and Gore's mantelpiece still-lives with their Chelsea figurines. Fergusson recalled that Gilman was 'a great painter of teapots',[18] and that most British object crops up in several pictures. In *The Old Lady* (no.19) the neat arrangement of the tea is reminiscent of the ritual described by Arnold Bennett in his contemporary novel *Buried Alive*. The protagonist, a painter, surveys his wife's tea-table: 'Silver ornamented the spread, and Alice's two tea-pots (for she would never allow even China tea to remain on the leaves for more than five minutes) and Alice's water-jug with the patent balanced lid, occupied a tray off the cloth. At some distance, but still on the table, a kettle moaned over a spirit lamp. Alice was cutting bread for toast'.[19] That cosy and customary teapot was an object of persistent significance for Gilman. To some, though, the 'native' qualities of the Camden Town painters obstructed their full assimilation of recent French art. 'Theirs is no vulgar provincialism', wrote Clive Bell in 1917, 'but, in its lack of receptivity, its too willing aloofness from foreign influences, its tendency to concentrate on a mediocre and rather middle-class ideal of honesty, it is, I suspect, typically British'.[20] A dimension that Bell did not take into account was the occasional use by Camden Town artists of French compositions as vehicles for British imagery. The example of Degas' ballet scenes of the later 1870s, such as *Fin d'Arabesque* or *L'Etoile* (Paris; Louvre), was adapted by Gore to the tongue-in-cheek jingoism of *Rule Brittania* (1910; Private Collection). *Mrs Mounter* (no.76†) is based on Cézanne's *Femme à la Cafetière* (fig.10), which Gilman would have seen when he visited the Pellerin collection in Paris in 1910 or 1911. The substitution of Cockney landlady for Provençal *bonne*, teapot for *cafetière*, ensured the British character of the painting. The Camden Town painters are often assessed in terms of their assimilation of French painterly practices, but they could also subject French motifs, no doubt half humourously, to a process of anglicization.

Until Gilman received the Halifax Harbour commission in 1918 the First World War seems, at first sight, to have made little impact on his art, if we exclude the portrait of a young captain he left unfinished (Private Collection). The war certainly affected his life, however. In a rare fragment of private information about the artist there is the evidence of his brother Leofric, a soldier, who had come to attend their father's burial in 1917: '... after breakfast I had a telegram recalling me so I never did attend the funeral. Harold came to see me off at Purley station and, when we said goodbye, there were tears in his eyes'.[21] Only the year before Ginner and Gilman 'formed a little club where friends could meet and paint during the winter evenings of 1916. Everyone enjoyed it and we all attended regularly until we were driven away by bombs', recalled Marjorie Lilly of the Pulteney Street school.[22]

Yet even before the Halifax Harbour painting there is a suggestion of the war's presence in Gilman's pictures, not as a subject, of course,

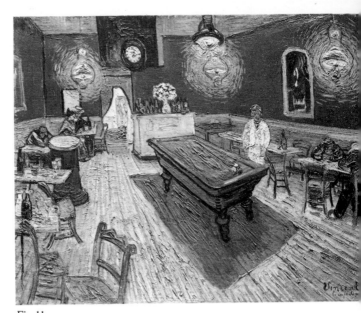

Fig. 11
V. van Gogh, *The Night Café* 1888
New Haven, Yale University Art Gallery – Bequest of Stephen Carlton Clark B.A. 1

but as a mood. A number of paintings of, say, 1916 and 1917 are permeated with a mood of loneliness and melancholy. The intense emotional identity of *Mrs Mounter* (no.76†) – her obstinate and vulnerable personality, her piteous stare and her matriarchal stability – is established by the coherent yet conflicting colouring of her face, hues whose tensions are stretched across firmly drawn features. This mask of multiple emotions is set against a spare arrangement of antagonistic colours, burnt orange and turquoise, dull purple-brown and dark green. *Mrs Mounter* is such an effective image because it is based on paradoxes; the bright colours one expects to be cheerful are strident and brittle, the matronly reassurance of her presence nevertheless has an aura of desolation and melancholy. A similar sense of isolation haunts the painting of Mrs Mounter in an interior (no.75*). Her position in the middle of the space, just off centre, and her subservient relationship to an interior of which she, in fact, is the owner, recalls the pathetic proprietor in Van Gogh's *Night Café* (fig.11).[23] There is no direct evidence, of course, to associate either of Gilman's images with the war, but their sense of loneliness and anxiety seem to reflect the tense world of the Home Front. With *Tea in the Bed-Sitter* (no.74*) such an association gathers plausibility. W have already seen how this picture is representative of Gilman's revived interest in an implicit narrative content, and how the picture arouses our curiosity about the two empty places laid for tea. In soci circumstances that should be animated by dialogue, the two figures

are silent and withdrawn. While *Tea in the Bed-Sitter* is a straightforward depiction of the Gilmans' Maple Street flat it is also, to some degree, a subject picture. Empty chairs and empty places ask for explanation. Perhaps we are helped by the recollection that the painting was exhibited during the summer that the Battle of the Somme was fought, and that 'by the end of 1916 there were few families untouched by personal grief. Each day at Charing Cross station a double line, mostly of women, waited patiently for disembarking troop trains; each day the newspapers carried a list of about 4,000 casualties'.[24] Those at home made efforts to disguise their private grief or cover up their anxieties, but may there not be in *Tea in the Bed-Sitter* an allusion to the strain of the war, particularly the strain on women? The war does seem to intrude on this picture, dictating the presences and the absences, and producing an atmosphere at odds with the gentle calm of other late interiors, notably those of Sylvia alone or with her baby.

That Gilman should approach war in such a tangential fashion is lent credence by his treatment of his major wartime project. In 1918 Gilman was commissioned to paint the harbour at Halifax as part of the Canadian War Records scheme. Despite the fact that the harbour had recently been ravaged by a huge explosion which devastated the town and killed hundreds of people the painting is, as Louis Fergusson was the first to note, 'remote from any active suggestions of war'.[25] Gilman painted Halifax harbour from a distance. He set himself to paint a landscape, not a war picture. He gave himself landscape painter's problems – how to cope adequately with the foreground, for example – and pushed the busy harbour, with its camouflaged cruisers, submarines and freighters, into the distance. From the first preparatory drawings for the painting a distaste for the warlike, and even the modern, mechanistic subject, is apparent. In the drawings Gilman kept the camouflaged ships of war as tiny, strangely marked aliens on the horizon. An unbelligerent dredger served as a point of interest, central and close to the painter; on this piece of equipment he lavished special attention, studying it carefully in a watercolour (no.104). The dazzle camouflage, designed during the war to break up the shapes of ocean-going vessels, aroused great enthusiasm for its visual potential, and artists like Edward Wadsworth, whom Gilman would have known,[26] were much involved with this modern fusion of the artist's skill and the needs of war. But Gilman unambitiously opted to play down the effect of the dazzle camouflage, merely using it to echo in the middle distance of his composition the insistent patterning of the important foreground slope. He chose not to concentrate on the vessels, as Wadsworth did in his well-known wood-cuts, or to detail the formidable armaments of the warships, like Lavery in his painting *The Guns of HM Monitor 'Terror'*.[27] Gilman's panorama of Halifax harbour is almost consciously calm, the warships strangers to the broad bay. A similar solution to the depiction of a port in wartime was found in the same

year, quite independently, by Gilman's old teacher Wilson Steer. In his painting of *Dover Harbour* (Imperial War Museum) Steer also relegated the warships to the distance and concentrated on the landscape painter's concerns; some two-thirds of his canvas represents sky. In *Halifax Harbour* Gilman produced a painting that Fergusson saw as 'a splendid space-composition suffused with radiant light', while a contemporary reviewer spoke of its 'satisfying serenity'.[28] These are hardly the comments one expects about a painting of a wartime scene. Gilman did not allow the circumstances to distract him from his painterly objectives; his *Halifax Harbour* is pacific, precisely observed and – at the last count – rather conservative.

Gilman's selection of his subjects was rarely startling, but he had the ability to stamp his artistic personality on a standard theme. The frankness of his nudes, and above all his insistence that the spectator respond directly to those naked figures, sets them apart from the more objectively or obliquely viewed nudes of Gore and Sickert. And yet, for all their importance, the nudes are rather isolated in Gilman's work because of their very demonstrativeness. He was an artist who developed at a regular pace, and no doubt observed the world around him as steadily. The recurrence of themes and especially the repetition of particular pictures testifies to his commitment to his subjects. Perhaps the overriding quality of Gilman's images is their sense of gravity and quiet, the result of his dogged concentration on what he had chosen to paint. The pinnacles of his career are perhaps neither the nudes, the subtly implied narratives of his interiors nor the controlled landscapes, but those paintings – *The Girl with a Teacup* (no.51†), *An Eating House*, the Mrs Mounter group – which, above all, Gilman infused with stillness, dignity and melancholy.

Notes

1 C. Ginner, 'Harold Gilman: An Appreciation'. *Memorial Exhibition of Works by the late Harold Gilman*, Leicester Galleries, October 1919, p.3.

2 T. Martin Wood, *Whistler*, London, n.d. (c.1905), p.61.

3 *Paul Cézanne-Mappe*, Munich, 1912.

4 M. Lilly, *Sickert. The Painter and his Circle*, London, 1971, p.149.

5 Lewis and Fergusson, p.28; National Gallery no.2490.

6 Ibid.

7 The copy, apparently to scale, is after *La Infanta Doña Margarita de Austria*, (1660; Prado no.1192).

8 R. A. M. Stevenson, *Velasquez*, 1895 (quoted from 1962 ed., p.92).

9 T. M(artin) W(ood), The New English Art Club's Summer Exhibition, *Studio*, 47, 1909, p.178.

10 G.R.S.T., The New English Art Club, *New Age*, 6 June 1907, p.91.

11 T. M(artin) W(ood), *Studio*, 1909, op. cit., p.180-3.

12 For the trip to Hendon see: Mellon Centre, 1980, p.47.

13 The bridge at Flekkefjord was built in 1838 (*Tate Gallery Catalogues. The Modern British paintings, drawings and sculpture*. Vol.I, London, p.235). For Van Gogh's paintings of Langlois bridge see: J-B. de la Faille, *The Works of Vincent van Gogh*, London, 1970, nos.397, 400, 570-1. Gilman is recorded as comparing one of his paintings of a bridge, probably no.41, to Van Gogh (Lewis and Fergusson, p.14).

14 *New Age*, 20 April 1911, p.588.

15 S. Hynes, *The Edwardian Turn of Mind*, Oxford/ Princeton, 1968, p.171.

16 Marie Stopes, *Married Love. A New Contribution to the Solution of Sex Difficulties*, London, 1918 (quoted from 1923 ed., pp.58-9).

17 C. Ginner, op. cit., p.5; Lewis and Fergusson, p.14.

18 Lewis and Fergusson, p.31.

19 A. Bennett, *Buried Alive*, London, 1912 (quoted from 5th. ed., 1913, pp.189-90).

20 C. Bell, Contemporary Art In England, *Burl. Mag*, July 1917, p.36.

21 Letter to Mrs Betty Powell, 8 January 1969.

22 Lilly, op. cit., p.130.

23 *The Night Café* was reproduced in the album of Van Gogh photographs (*Van Gogh-Mappe*, Munich, 1912) that Gilman owned.

24 A. Marwick, *The Deluge. British Society and the First World War*, 1965 (quoted from 1967 ed., p.142).

25 Lewis and Fergusson, pp. 31-2.

26 Wadsworth had been a fellow pupil of Sylvia Hardy at the Slade, and painted her portrait in 1911.

27 For Wadsworth's woodcuts see *Edward Wadsworth, 1889-1949*, Colnaghi's, July-August 1974, nos.128-34. There is a photograph of the Lavery in the Witt Library.

28 Lewis and Fergusson, p.32; R. S., The Canadian War Memorials Exhibition, *Burl. Mag*, February 1919, p.80.

LIST OF EXHIBITIONS

1904 June, **1909** Winter, **1910** June, **1910** Winter, **1914** June. New English Art Club.

1908 March, **1909** March, **1910** March, **1912** March, **1913** March. Salon des Indépendants, Paris.

1908 July onwards, regular exhibitor. Allied Artists Association.

1911 June, **1911** December, **1912** December. Camden Town Group.

1913 January. 'Paintings by Harold Gilman and Spencer Gore'. Carfax & Co.

1913 October. 'Post-Impressionist and Futurist Exhibition'. Doré Gallery.

1913 December. 'English Post-Impressionists, Cubists and Others'. Brighton Art Gallery.

1914 March, **1915** March and November, **1916** June and November, **1917** April, **1918** May, **1919** April. London Group.

1914 April. 'Paintings by Harold Gilman and Charles Ginner'. Goupil Gallery.

1914 May. 'Twentieth-Century Art. A Review of the Modern Movements'. Whitechapel Art Gallery.

1915 April. Cumberland Market Group. Goupil Gallery.

1919 January. Canadian War Memorials Exhibition. Royal Academy of Arts.

1919 October. 'Memorial Exhibition of Works by the late Harold Gilman'. Leicester Galleries.

1928 June. London Group Retrospective Exhibition. New Burlington Galleries.

1930 January. 'The Camden Town Group. A Review'. Leicester Galleries.

1934 September. 'Paintings by Harold Gilman 1876–1919'. Arthur Tooth & Sons.

1939 March. 'The Camden Town Group'. Redfern Gallery.

1943 September. 'Paintings by Harold Gilman'. Lefevre Gallery.

1944 'The Camden Town Group'. Council for the Encouragement of Music and the Arts (CEMA).

1948 March. 'Selected Paintings, Drawings and Sculpture in the Collection of the late Hugh Blaker'. Leicester Galleries.

1948 July. 'Paintings and Drawings by Harold Gilman 1876–1919'. Lefevre Gallery.

1948 September. 'The Collection of Sir Louis Fergusson KCVO'. Leicester Galleries.

1950 November. 'Paintings by some Members of the Camden Town Group'. Lefevre Gallery.

1951 June. 'The Camden Town Group'. Southampton Art Gallery.

1953 'The Camden Town Group'. Arts Council travelling exhibition.

1954–5 'Harold Gilman 1876–1919'. Arts Council travelling exhibition.

1961 'Camden Town Group Fiftieth Anniversary Exhibition'. Minories, Colchester.

1961–2 'Drawings of the Camden Town Group'. Arts Council travelling exhibition.

1963 April. 'A Painter's Collection. Paintings, Drawings and Sculpture from the Collection of the late Edward Le Bas RA'. Royal Academy of Arts.

1964 July. London Group Jubilee Exhibition. Tate Gallery.

1964 'Harold Gilman 1876–1919'. Reid Gallery.

1965 May. 'The Camden Town Group'. Hampstead Town Hall.

1965 'Decade 1910–1920'. Arts Council travelling exhibition.

1967 'The Camden Town Group and English Painting 1900–1930s'. William Ware Gallery.

1969 'Harold Gilman 1876–1919. An English Post-Impressionist'. Colchester, Oxford, Sheffield.

1974 May. 'The Camden Town Group'. Plymouth Art Gallery.

1974 September. 'The Camden Town Group'. Laing Art Gallery, Newcastle upon Tyne.

1975 April. 'English Paintings from the Bevan Collection'. Anthony d'Offay Gallery.

1975 July. 'The R. A. Bevan Collection'. Minories, Colchester.

1976 October. 'Camden Town Recalled'. Fine Art Society.

1978 August. 'The Bevan Collection'. Gainsborough's House, Sudbury.

1979 November. 'Post-Impressionism'. Royal Academy of Arts.

1980 April. 'The Camden Town Group'. Paul Mellon Centre for British Art, Yale University.

1980–81 'More than a Glance'. Arts Council travelling exhibition.

BIOGRAPHY

The artist in his studio

11 February. Harold John Wilde Gilman born at Rode, Somerset, son of a Church of England parson. Educated at Abingdon, Rochester and Tonbridge schools. While at Tonbridge injured his hip in an accident, and was incapacitated for eighteen months, during which time he first became interested in art. His father was then, and was to remain till his death in 1917, Vicar of Snargate with Snave on Romney Marsh.

Spent one year at Oxford as a non-collegiate student; left on account of his health.

Went to Odessa for a year as tutor to the children of an English family.

Attended Hastings School of Art.

At the Slade School of Art.

Recorded as living for a time in Notting Hill with his brother Leofric.

or possibly late **1901**. Went to Spain where, on his own evidence (*Art News*, 28 April 1910), he spent more than a year. He copied Velasquez paintings in the Prado, and could have met his Slade contemporaries Spencer Gore and Wyndham Lewis while in Madrid. He is known to have been back from Spain by October 1903.

2 February. Married Grace Canedy, a painter from Chicago, in Madrid.

19 January. His daughter Elizabeth born at 128a Lancaster Road, Notting Hill.

First showed at the NEAC (not again until 1909). His address given in the catalogue was at Pangbourne, Berkshire.

Early, or possibly late **1904**. A long visit to his wife's family in Chicago, during which his father-in-law tried to persuade Gilman to join his business.

4 February. His daughter Hannah born in Chicago.

2 November. His son David Richard born at 37 Barton Street, Kensington; the child died at Snargate, 21 January 1907.

1907 Gilman met Walter Sickert in a chance encounter in February, and became a founder-member, with Sickert, Gore and Albert Rutherston, of the Fitzroy Street group which began in the spring to meet regularly on Saturday afternoons at 19 Fitzroy Street, to exhibit and sell their paintings.

1907 Summer. Sickert lent the Gilmans his house at Neuville outside Dieppe; they may have spent the best part of a year in Dieppe.

1908 March. First exhibited at the Salon des Indépendants, Paris.

1908 July. Showed at the first exhibition of the Allied Artists Association at the Albert Hall. The AAA, a jury-free association modelled on the Indépendants in Paris, was the brainchild of Frank Rutter, art critic of the *Sunday Times*, who sometimes attended the Fitzroy Street meetings. Grace Gilman also showed at the AAA, and their address was given in the catalogue as Snargate.

1908 20 September. His son David born at Letchworth, Herts; this is the first evidence of the Gilmans having moved there.

1909 Summer. His wife and children visited Chicago and did not return. Divorce followed in 1917.

37

The artist's mother

1910 April and May. Published two short articles in *Art News*, a new journal edited by Frank Rutter.

1910 July. On the hanging committee of the AAA together with Gore and Charles Ginner.

1910 October. 'Manet and the Post-Impressionists' exhibition organized by Roger Fry at the Grafton Galleries.

1910 late, or **1911**. A crucial visit to Paris with Ginner and Rutter, to see collections of modern paintings, including Pellerin and Durand-Ruel collections, Vollard and Sagot galleries. Possibly on the same trip visited Sickert at Dieppe and painted the Dieppe pictures generally ascribed to 1911.

1911 June. The first exhibition, at the Carfax Gallery, of the Camden Town Group which Gilman had taken the initiative in forming during the previous winter.

1911 December. Second exhibition of the Camden Town Group.

1912 August to November. Gore took over Gilman's house at Letchworth while Gilman visited Sweden.

1912 October. 'The Second Post-Impressionist Exhibition' organized by Fry at the Grafton Galleries.

1912 December. The third Camden Town Exhibition.

1913 January. Joint exhibition with Gore at the Carfax Gallery. Gilman's address given in the catalogue a Snargate.

1913 July. Gilman and Ginner exhibited for the first time, at the AAA, as 'Neo-Realists'.

1913 Summer. Visited Norway.

1913 October. Frank Rutter organised 'Post-Impressionists and Futurists' exhibition at the Doré Gallery. Gilman represented.

1913 November. Foundation of the London Group wit Gilman as President.

1913 December. 'English Post-Impressionists, Cubists and Others' exhibition at Brighton Art Gallery. Gilman represented.

1914 Acquired his first permanent address in London; 47 Maple Street, off Tottenham Court Road, where he lived till 1917.

1914 3 February. Interview with Gilman published in the *Standard*.

1914 March. First exhibition of the London Group.

1914 April. Gilman and Ginner exhibited jointly as Neo-Realists at the Goupil Gallery. Ginner's article 'Neo-Realism', published in the *New Age*, 1 January, 1914, used as a catalogue introduction.

1914 Following the death of Gore in March Gilman took over the evening class teaching at the Westminster Institute which Gore had inherited from Sickert.

1914 June–July. Sickert's attack on Neo-Realism in the *New Age* led to exchange of letters.

1914 late. Formation of the Cumberland Market Grou with Gilman, Ginner and Bevan as core members

1915 April. Cumberland Market exhibition at the Goupil Gallery.

1915 Autumn. Gilman embittered by Sickert's taking back his teaching post at the Westminster Institut

1916 January. Started, with Ginner, to teach evening classes at a school they established at 16 Little Pulteney Street, Soho. The school was closed by Gilman in December 1917 after Ginner had already left on war service.

The artist's second wife, Sylvia, and child

Summer. Painted with Hubert Wellington at
Sapperton, Gloucestershire.

July. Co-editor, with Ginner and Rutter, of the
first issue of *Art and Letters*; Gilman's name
disappeared from the masthead after issue 1.

late summer. Married Sylvia Hardy, a painter
whom he had met when she was a student at the
Westminster Institute probably in 1914. The
honeymoon was spent at Wells, and they then
lived briefly with Sylvia's parents at Cheyne Walk,
Chelsea, before moving to 53 Parliament Hill
Fields, Hampstead.

13 December. His son John born.

Gilman on the Council of the AAA, having been
secretary in 1916.

Visited Halifax, Nova Scotia, for the Canadian
War Records.

12 February. Died in hospital of influenza.

October. Memorial Exhibition at the Leicester
Galleries followed the publication in the summer of
Harold Gilman. An Appreciation by Wyndham
Lewis and Louis Fergusson.

CATALOGUE

Measurements are given in inches and centimetres, height preceding width. All paintings are on canvas, unless stated otherwise.

1 Portrait of Spencer Frederick Gore 1898–9
Pencil 10¾ × 7¼ (27·5 × 18·3)
Signed lr: 'Harold Gilman' and inscribed below: 'drawing of Spenser [sic] Frederick Gore/at the age of 20'
Exh: New York, World's Fair, *Contemporary British Art*, 1940 (55); Leicester Galleries, Sept 1948 (55); Southampton, 1951 (35); Leicester Galleries, *New Year Exhibition*, 1957 (25)
Prov: Sir Louis Fergusson; Denys Sutton; to present owner, 1957 (Bevan Fund)
Lent by the Visitors of the Ashmolean Museum, Oxford

Spencer Gore (1878–1914) attended the Slade School, where he was a contemporary of Gilman, Wyndham Lewis and Augustus John, from 1896–9. This drawing must have been made during this time, though the inscription (in Gilman's hand) would seem to be a later addition. No other sheets from Gilman's Slade period survive; Lewis remembered that Gilman's life drawing was unimpressive (Lewis and Fergusson, p.12). Sir Louis Fergusson, Gilman's friend and contributor to his biography, was private secretary to successive Chancellors of the Duchy of Lancaster (1909–21) and Clerk of the Council of the Duchy (1927–45). He died in 1962.

2 Willows by a River Pre-1905
Oil 12⅞ × 14¾ (32·7 × 37·6)
Stamped signature lr
Prov: Barbara Duce; Agnew; Leger Gallery
Lent from a Private Collection

This canvas is the earliest extant landscape painting by Gilman. The location is unknown; it might be Romney Marsh, where the artist's father had his living, or the Thames Valley, for in 1904 Gilman lived in Pangbourne (Baron, 1979, p.73, n.13). The freedom of touch, especially the broad handling of the foliage, is reminiscent of Steer, Gilman's teacher at the Slade, and, via Steer's recent paintings, of Constable. The grey-green tonality recalls Corot, whose contemporary reputation was high; Gore's early canvases are also Corotesque.

3 Portrait of a Seated Woman 1902–4?
Oil 13½ × 8½ (34·3 × 21·6)
Stamped signature lr
Prov: the artist's family
Lent by the artist's family

According to family tradition, the sitter may be the youngest sister of Rev. Gilman, known as Aunt Christie. The detailed observation and smooth surface of this canvas are typical of Gilman's early figure paintings. The artist himself remarked at a much later date that another early canvas, *A Lady at the Piano* (collection unknown) was 'almost like an Alfred Stevens', referring to the Belgian painter (1823–1906) celebrated for his highly finished paintings of bourgeois life (Lewis and Fergusson, p.20).

***4 Portrait of a Lady** 1905?
Oil 21⅜ × 21⅜ (54·3 × 54·3)
Stamped signature lr
Lit: Aberdeen Art Gallery, *Annual Report*, 1957 (repr.); Aberdeen Art Gallery, *Permanent Collection Catalogue*, 1968, p.51
Prov: Sylvia Gilman; Barbara Duce; to present owner, 1957 (purchased Murray Fund)
Lent by Aberdeen Art Gallery & Museums

This is the most important portrait of Gilman's first wife Grace (née Canedy). A number of portraits of her exist, including one in the collection of the Marquess of Salisbury (exh. Colchester, 1969, I) and another belonging to the artist's family. The square format of the canvas was unusual for Gilman. *Portrait of a Lady* hangs on the wall to the upper left of Gilman's later painting *Edwardian Interior*, which depicts the drawing-room at Snargate Rectory (c.1907; Tate Gallery).

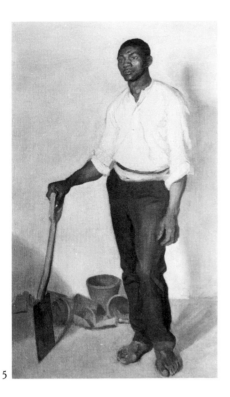

5

*5 The Negro Gardener 1905?
Oil 52⅜ × 30½ (133 × 77·5)
Unsigned
Exh: Ware Gallery, 1967 (55); Agnew,
20th-Century British Art, Nov–Dec 1972 (2)
Lit: Fairfax Hall, 1965, p.17; B. N(icolson),
Current and Forthcoming Exhibitions, Burl. Mag,
Dec 1972, p.876, repr. p.878; Baron, 1979, p.367
Prov: L. H. Gilman (artist's brother); Peter
Langan
Lent by Odin's Restaurant

This canvas was probably painted in 1905 during a
visit to the United States. Nicolson (loc. cit.)
suggested the influence of the legacy of Thomas
Eakins on the *Negro Gardener*. It is, however,
unclear how long Gilman was in the United States
and thus how much opportunity he had to study
contemporary American painting. Eakins, like
Gilman, had admired Velasquez, and the *Negro
Gardener* belongs to the Spanish tradition of
portraiture.

6 Portrait of Spencer Gore 1906–7
Oil 14½ × 12½ (36·8 × 31·7)
Signed on verso: 'H. Gilman'
Exh: Leicester Galleries, 1919 (1?); Southampton
1951 (23); Arts Council, 1953 (18); Arts Council,
1954–5 (3); Colchester, 1969 (4); Fine Art
Society, 1976 (23)
Lit: M. de Sausmarez, *Leeds Arts Calendar*, Sprin
1950, p.14, repr. p.15; D. Farr, *Burl. Mag,* June
1955, p.184; Baron, 1979, p.367; Watney, p.41,
repr. p.43
Prov: acquired by present owner, 1936
Lent by Leeds City Art Galleries

Having met at the Slade in the late 1890s (see no. 1
Gore and Gilman seem to have lost contact. They
may have met again in Spain in 1902. By 1907, the
year that Gilman became involved with Sickert an
the Fitzroy Street circle, Gore and he had
re-established the friendship and collaboration
that would last until Gore's death in 1914. The
tonal range and fluent touch tallies with other
canvases of the same period, for instance the
Artist's Sister Seated in a Window (Anthony
d'Offay). Gilman painted another portrait of Gore
about 1910–11 (Private Collection). For a
photograph of Gore c.1908 see *Spencer Frederick
Gore, 1878–1914*, Anthony d'Offay, 1974, p.4.

7 In Sickert's House, Neuville 1907?
Oil 23½ × 18 (60·3 × 45)
Signed lr: 'H. Gilman'. Inscribed on verso 'H.
Gilman 19 Fitzroy Street'
Exh: Indépendants, 1908 (2533?); AAA, 1908
(1387?); Arts Council, 1954–5 (7); Colchester,
1969 (8); Fine Art Society, 1976 (24); Royal
Academy, 1979 (293, repr.)
Lit: M. de Sausmarez, *Leeds Arts Calendar*, Sprin
1950, p.14, repr. p.13; Baron, 1979, p.367
Prov: Sylvia Gilman
Lent by Leeds City Art Galleries

Between about 1905 and 1908 Gilman painted a
number of interiors depicting rooms in which he
and his family lived or lodged. A few of them are
earlier than *In Sickert's House*, to judge from their
less confident handling. *The Nursery, Snargate*
(London, Fox Fine Art), for instance, was probab
painted c.1905–6. Gilman and his family rented
Sickert's house at Neuville, on the outskirts of
Dieppe, in 1907. An eye-witness account of the
Neuville accommodation, which stressed 'the bare
scrubbed tables and simple furniture', would seem
to establish the identity of the Leeds interior
(Hubert Wellington, 'With Sickert at Dieppe',
Listener, 23 Dec, 1954, p.110). Curiously,
Wellington was of the opinion that no.7 depicted

Gilman's Letchworth home, implying a date of 1908–9, too late for the rather liquid handling of the painting. Anna Greutzner has plausibly suggested that *In Sickert's House* was shown at the Indépendants in May 1908 as *Intérieur Vert* and at the AAA in July that year as *Green Door, Interior* (Royal Academy, loc. cit.). The Tate Gallery's *French Interior* probably also dates from the 1907 visit to Neuville.

Interior 1908?

Oil 27 × 23¼ (68·5 × 59·1)
Stamped signature lr
Exh: Tooth, 1934 (2?); Colchester, 1969 (10, repr.)
Prov: The artist's family; acquired by the present owners, 1955
Lent by Lord and Lady Walston

The rich pale gold tonality of *Interior* and *the Kitchen* (no.9) would seem to place them slightly later than the cooler toned canvases of the previous year. *Interior* was probably painted at Snargate Rectory; it represents the artist's wife and, according to Mrs Barbara Duce, his daughter Hannah with a maid called Sarah. At least two other interiors survive that have a similar touch and tonality and which may also have been painted at Snargate c.1907–8: *Interior* (Southampton Art Gallery) and the so-called *Edwardian Interior* (Tate Gallery).

The Kitchen 1908?

Oil 24 × 18 (61 × 45·8)
Stamped signature lr
Exh: Leicester Galleries, 1919 (35?); Lefevre, 1948 (1); Leicester Galleries, *Artists of Fame and Promise*, 1955 (55); Arts Council, *Exhibition of Purchases by the Contemporary Art Society for Wales*, 1967 (11)
Lit: *A List of Paintings and Sculpture in the National Museum of Wales*, 1972, n.p.; Baron, 1979, pp.20, 172, 366, repr. pl.46
Prov: presented to the present owner by the Contemporary Art Society for Wales, 1957
Lent by the National Museum of Wales, Cardiff

Dated 1905 in the 1948 Lefevre catalogue, this canvas should be placed a few years later on the grounds of Gilman's sophisticated handling of reflected light, notably on the open door, and his increasing observation of colour in the shadows. The problem of location is unresolved. Neuville is most unlikely, precluded by stylistic features and the decidedly English design of door and handle. Again, it may be Snargate that is represented, but

Baron has suggested the house at 15 Westholme Green, Letchworth, where the family lived from the summer of 1908 until Grace Gilman's departure in 1909 (Baron, 1979, p.172). Another canvas of a domestic servant, *The Cook* (repr. *Studio*, December 1944, p.184), is probably of similar date.

10 The Thames at Battersea 1907–8

Oil 23 × 36 (60 × 91)
Signed lr: 'H. Gilman', followed by erased date
Exh: Lefevre Gallery, *20th-Century British Painters*, Aug 1950 (12?); Southampton, 1951 (22); Dundee Museum, *English Paintings, 1900–1950*, 1979 (4, repr.)
Lit: Rothenstein, 1952, p.148; *Kirkcaldy Museum and Art Gallery, Catalogue of Paintings*, 1965, p.6; Baron, 1979, pp.20, 27, 172, 367, repr. pl. 47
Prov: Sylvia Gilman; Lefevre Gallery; acquired by the present owner, 1951
Lent by Kirkcaldy Art Gallery

A smaller painting of the same period, *The Thames at Chelsea* (sold Sotheby's, 15 December 1971, 27), also gives evidence of Gilman's apparently brief activity as a painter of cityscapes in the later 1900s. The size of *The Thames at Battersea* suggests that it was intended for exhibition, but there is no record of its being shown. Perhaps Gilman was dissatisfied with such a blatantly Whistlerian subject, though the tonal range recalls followers such as Paul Maitland rather than Whistler himself. The canvas shows signs of reworking in passages, notably the hull of the steamer, on which green has been painted over an earlier red layer; such revision may account for the erasion of the date.

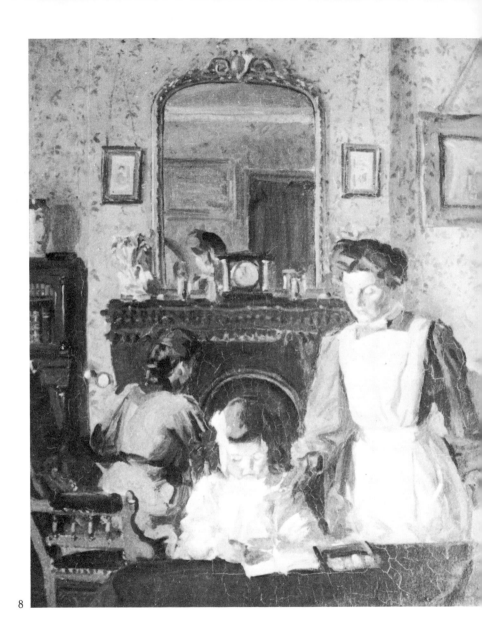

8

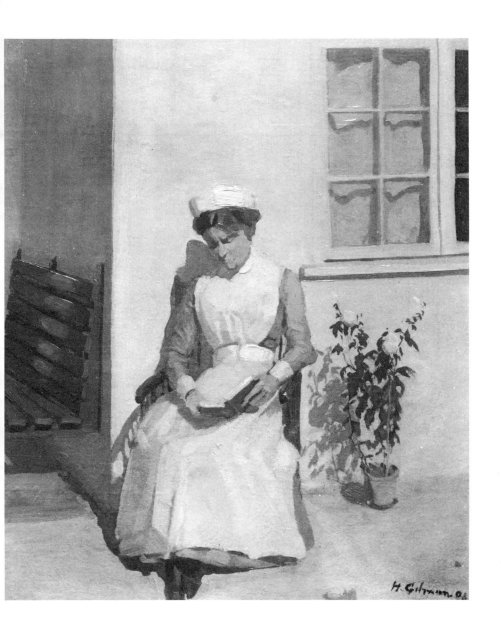

45

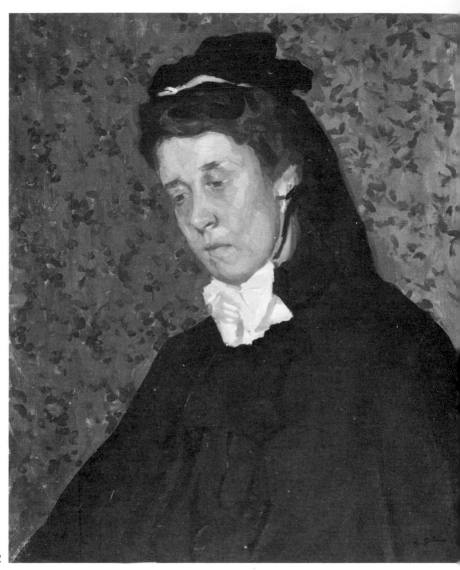

12

1 The Nurse 1908
Oil 24 × 20 (61 × 50·8)
Signed and dated lr: 'H. Gilman 08'
Exh: Agnew, 1968 (5); Colchester, 1969 (7);
Arts Council, 1980–1 (28, repr.)
Prov: Agnew; acquired by the present owner,
1968
Lent by Mrs Guy Hannen

In this painting Gilman concentrated on the tonal
structure of the motif, particularly stressing the
sharp contrasts of value produced by strong
sunlight. It has been suggested that the nurse is
the same as the one who appears in *In Sickert's
House* (no.7) and *Interior* (no.8) (Colchester, loc.
cit.). The location of this canvas is unknown, but
the modern window and bench would seem to
argue for Letchworth rather than Snargate.

2 The Nurse 1908?
Oil 24¼ × 20⅛ (61·4 × 51·1)
Stamped signature lr
Exh: Birmingham, *The Early Years of the New
English Art Club, 1886–1918*, 1952 (23); Arts
Council, 1953 (20); Arts Council, 1954–5 (11);
Agnew, *Loan Exhibition of Pictures from the City
Art Gallery, Birmingham*, 1957 (69); Royal
Academy, *Primitives to Picasso*, 1962 (272);
Colchester, 1969 (12)
Lit: Birmingham Museums and Art Gallery, ·
*Illustrations of 100 Oil Paintings in the Permanent
Collection*, 1952, p.16 repr.; Birmingham
Museums and Art Gallery, *Catalogue of Paintings*,
1960, p.61; Q. Bell, *Motif*, 11, Winter 1963–4,
p.74, repr. p.80; Baron, 1979, pp.172, 366
Prov: Lefevre Gallery; presented by the Friends of
the Art Gallery, 1947
Lent by Birmingham Museums and Art Gallery

The Nurse is a fine example of Gilman's work at an
important transitional phase. The thinly applied
paint and careful arrangement of subdued tones
are consistent with much of his work of this
decade, but here livelier colour and a more broken
touch begin to play an increasingly significant role.

Portrait of an Algerian 1908?
Oil 17 × 14 (43·2 × 35·6)
Unsigned
Exh: Arts Council, 1954–5 (7)
Prov: Wyndham T. Vint
Lent by the Vint Trust

The sitter is unknown, as are the reasons for
identifying him as an Algerian. Perhaps the
inspiration for such a work came from the example

14

of Velasquez, and such pictures as *Juan de Pareja*
(1650; New York, Metropolitan Museum), which
in Gilman's day was in an English collection.

***14 Woman Sewing** 1908–9?
Pencil 9⅝ × 7¼ (24·5 × 18·3)
Signed lr: 'H. Gilman'
Exh: Lefevre, 1943 (29?); Lefevre, 1948 (1)
Prov: Lefevre Gallery
Lent by the Victoria and Albert Museum, London

Very few drawings made by Gilman before about
1910 still exist and consequently such remaining
sheets are most difficult to date with precision.
Woman Sewing is characteristic of the
draughtsmanship taught at the Slade and shows
the lasting effect of this training. A date of 1907
was given for this sheet in the 1948 Lefevre
catalogue, perhaps on the authority of the artist's
widow. A slightly later date is preferred here,
given the consonance of subject with a canvas of
c.1908–9, *Woman Sewing* (formerly Roland,
Browse and Delbanco), a portrait of the artist's
wife Grace. The model for this drawing is
unidentified.

15 Still-life 1909–10?
Oil 12⅜ × 16⅜ (31·4 × 41·6)
Stamped signature lr
Exh: Lefevre, 1948 (12); Bedford, Cecil Higgins
Art Gallery, *The Camden Town Group*, Oct–Nov,
1969 (15); Fine Art Society, 1976 (31)
Lit: J. W. Goodison, *Fitzwilliam Museum,
Cambridge. Catalogue of Paintings. III, British
School*, Cambridge, 1977, pp.86–7; Baron, 1979,
pp.140, 366, repr. pl.25
Prov: Mrs John Gilman (the artist's mother);
Lefevre Gallery; Captain Stanley William Sykes;
his gift to the present owner, 1948
Lent by the Fitzwilliam Museum, Cambridge

It has been suggested (Baron, p.140) that this
painting was shown at the Gilman/Gore exhibition
in 1913 as *The Mantelpiece*. This proposition is
most unlikely; Gilman always tended to exhibit
recent work and the Fitzwilliam canvas does not
depict a mantelpiece, but rather a sideboard, as the
height of the foreground chair insists. The small
frame leaning against the wall to the left would
appear to contain a painted sketch after a Velasquez
Infanta.

***16 The Blue Blouse: Portrait of Elène
Zompolides** 1910
Oil 24 × 18 (61 × 45·7)
Signed ll: 'H. Gilman'
Exh: NEAC, Summer 1910 (257); Tooth, 1934
(6); Redfern Gallery, 1939 (58?); Lefevre, 1943
(9); Arts Council, 1954–5 (13); Colchester, 1969
(13); Bedford, Cecil Higgins Art Gallery, *The
Camden Town Group*, Oct–Nov, 1969, (12); Fine
Art Society, 1976 (27); Mellon Centre, 1980
(28, repr.)
Lit: M. de Sausmarez, *Leeds Arts Calendar*,
Spring 1950, pp.14–15, repr. colour p.11; Baron,
1979, pp.28, 30, 198, 367, repr. pl.64
Prov: Lefevre Gallery; acquired by the present
owner, 1944
Lent by Leeds City Art Galleries

An undated note by Sir Philip Hendy in the Leeds
City Art Gallery records states – probably on the
evidence of Gilman's widow – that *The Blue
Blouse* was painted in the Letchworth house of
William Ratcliffe, a friend and neighbour of
Gilman. Nothing is known of Elène Zompolides;
she is thought to have been a friend of the artist.
The canvas was probably painted in early 1910,
ready to be exhibited at the NEAC that summer.
The dense application of loaded dabs of paint
marks an important change in Gilman's execution.

†17 The Breakfast Table 1910
Oil 27 × 20¾ (60·6 × 52·7)
Stamped signature lr
Exh: NEAC, Winter 1910 (147?); Redfern
Gallery, 1939 (34?); Lefevre, 1948 (13); Arts
Council (Western Region), *English Portraits,
1850–1950*, May–Aug 1950 (17); Southampton,
1951 (25); *Decade 1910–1920*, May–Sept, 1965
(41); Folkestone, Arts Centre, *Edwardian
Festival, 1895–1916*, June–July, 1974 (15);
Newcastle, 1974 (16); Le Havre, Musée des
Beaux-Arts, *Twinning Exhibition*, Oct–Nov, 1975
(8)
Lit: B. N(icolson), 'Sickert and Camden Town,'
Burl. Mag, Sept 1951, p.304, n.3; Harrison, *Stua
International*, Sept 1974, repr. p.76; Baron, 1979
p.368; Watney, p.41, repr. p.43
Prov: Philip James; Lefevre Gallery; Chipperfie
Bequest to present owner, 1948
Lent by Southampton Art Gallery

At the NEAC exhibition in late 1910 Gilman
showed one work, entitled *Portrait*. The critic of
the *Art News* wrote admiringly of it, and his
remarks could possibly refer to *The Breakfast
Table*: 'One of the few really interesting portraits
here is that of a lady (147) by Mr. Harold Gilman
and this is really notable for its uncompromising
honesty of vision as well as for its beauty of colou
(M.S., New English Art Club, *Art News*, 15
October 1910, p.20). The highly finished quality
The Breakfast Table and its prim and patterned
domestic setting are in complete accord with the
type of interior scene then favoured by NEAC
artists, for example Steer's *The Morning Room*
(repr. *Studio*, no.44, 1908, p.137) and Walter
Russell's *The Letter* (repr. ibid, no.47, 1908,
p.252). *The Breakfast Table* was apparently
painted from a house on the Embankment and
depicts one of the artist's sisters. *Lady on a Sofa*
(Tate Gallery), painted at about the same time,
also shows a sister of Gilman's (information fron
Mrs Betty Powell) though it is not clear if the sar
sitter is represented.

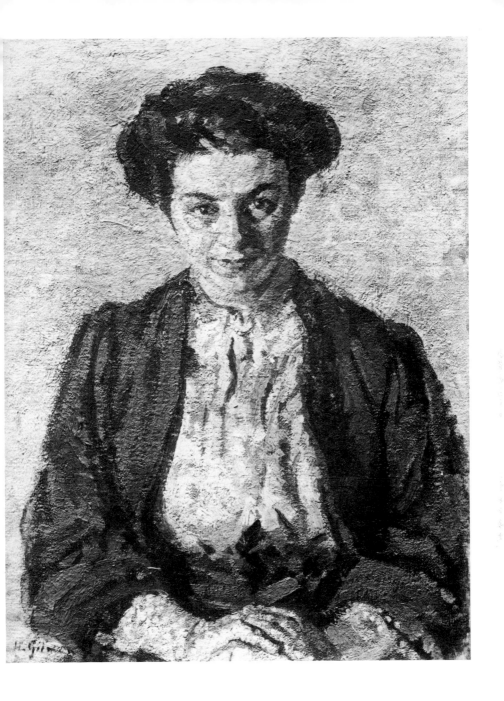

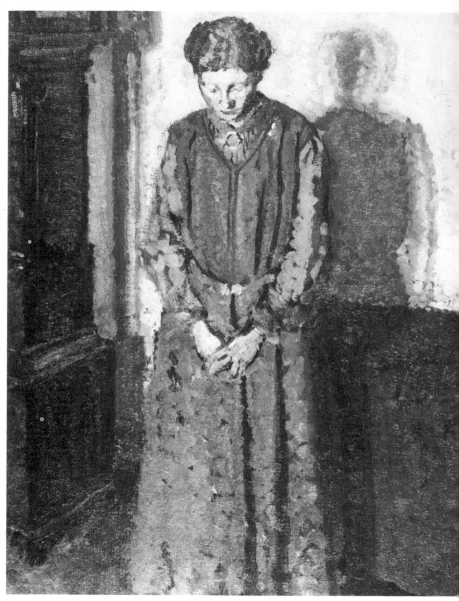

18

Meditation 1910–11
Oil 24⅜ × 18¼ (62 × 46·5)
Unsigned
Exh: Lefevre, 1943 (15?); Colchester, 1961 (15)
Lit: Baron, 1979, p.138
Prov: Mr and Mrs F. A. Girling; Agnew; Private
Collection
Lent by Leicestershire Museum and Art Gallery

Baron relates *Meditation* to a portrait in the
National Gallery of Victoria, Melbourne, and to
Portrait of Madeline Knox (Private Collection),
both of 1910–11. Certainly *Meditation* and
Madeline Knox are linked by still and pensive
poses, handling and almost identical size. Miss
Knox probably posed for *Meditation*. She was
closely associated with Sickert between 1908 and
1911, first as a pupil and later as the organizer of
his private art school. If *Meditation* does depict
Miss Knox, it must have been painted before her
departure for Canada, probably in 1911, and not
after her return (c.1914–15), when she married
Arthur Clifton of the Carfax Gallery (Baron, loc.
cit.).

The Old Lady 1911?
Oil 13½ × 11¾ (34·2 × 29·8)
Unsigned. Inscribed on stretcher by Blaker:
'Portrait of a Lady Harold Gilman 19 Fitzroy St.
Bought of the Artist'
Exh: Leicester Galleries, 1919 (19 or 25?, both
The Artist's Mother); Leicester Galleries, March
1948 (86); Arts Council, *Contemporary Paintings*,
1948 (3); Bordeaux, Musée des Beaux-Arts,
Bristol à Bordeaux, 1949–50 (6); Arts Council,
1953 (24); Arts Council, 1954–5 (33)
Lit: C. Gordon, London Commentary, *Studio*,
June 1948, repr. p. 189; City Art Gallery, Bristol,
Catalogue of Oil Paintings, 1970, p.46; Baron, 1979,
pp.225, 366
Prov: Hugh Blaker; Leicester Galleries to present
owner, 1948
Lent by the City of Bristol Museum and Art
Gallery

Gilman's mother sat for this picture, as she did on
many other occasions (nos.20, 78–81, 88).
The dabbed touch and heightened palette of *The
Old Lady* are characteristic of other paintings of
the same sitter made about 1911–12, including
The Artist's Mother at Lecon Hall (Aberdeen Art
Gallery) and the portrait in the Tate Gallery, which
is probably the one shown at the AAA in July
1912 (230) as *Thou Shalt not Put a Blue Line Round
thy mother*. The execution of *The Old Lady* is
reminiscent of Vuillard, whose work Gilman
would have seen on his recent visit to France and

who exhibited in London at the International
Society in 1910. Baron has suggested (p.225) that
The Old Lady was probably shown at the first
Camden Town Group exhibition in June 1911 as
Head of an Old Woman (55), though a more likely
candidate, judging from critics' descriptions,
would be *An Old Lady* (sold Sotheby's, 21
November 1973, 52 repr.).

20 The Artist's Mother Reading 1911?
Chalk with slight heightening in bodycolour on
India paper 10½ × 8 (26·1 × 20·2)
Unsigned
Lent by Birmingham Museums and Art Gallery

This sheet can be tentatively dated to about 1911
due to its relationship in subject and pose to
paintings such as *The Old Lady* (no.19). From
about 1912–13 Gilman began to draw increasingly
in pen and ink, the predominant medium for his
later drawings, including the series of his mother
in bed executed c.1917 (nos.78–81) to which the
present sheet looks forward.

†21 **Nude** 1911?
Oil 19¾ × 13¾ (50·2 × 34·9)
Unsigned
Exh: 2nd Camden Town exh., Dec 1911 (20 or
22?)
Prov: R. G. Hobbs; Sotheby, 18 July 1973
(121A)
Lent by the Mayor Gallery

Both the touch and palette of this canvas seem to
endorse a date of 1911; it is thus one of Gilman's
earliest known nudes. As Wendy Baron has pointed
out (1979, p.227), no nudes were shown at the
Gilman/Ginner exhibition of April 1914, and the
artist's interest in the subject was probably
limited to the three years 1911–13. It is possible
that not all Gilman's nudes are known, so the exact
order of their execution and the identification of
exhibited works – for example the four numbered
nudes shown at Gilman/Gore, January 1913 – are
difficult to assess. *The Times'* review of the second
Camden Town Group exhibition (11 December
1911) complained that Gilman's 'two very able
nudes. . . look as if they were sitting to be painted'
and this comment might have applied to nos.21
and 24.

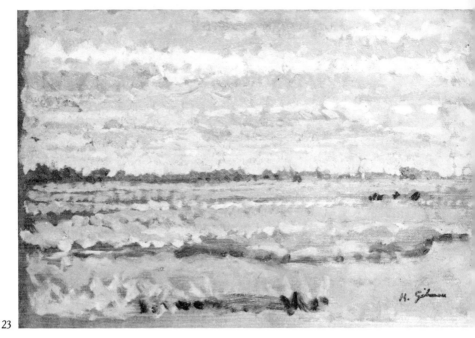

23

22 Girl by a Mantelpiece 1911–12
Oil 16 × 11⅞ (40·6 × 30·2)
Unsigned
Exh: Gilman/Gore, 1913 (50? *The Mantelpiece*);
Redfern Gallery, 1939 (53); Lefevre, 1943 (4?);
Southampton, 1951 (28); Le Bas, 1963 (127)
Lit: *Studio*, Nov 1945, repr. colour p.136; ibid,
June 1955, repr. p.169; Fairfax Hall, 1965, repr.
pl.3
Prov: Lefevre Gallery; Edward Le Bas; Agnew to
the present owner, 1979
Lent by the City Museum and Art Gallery,
Stoke-on-Trent

The unidentified girl seems to be standing by the
same mantelpiece as Gilman used for his *Portrait
of Madeline Knox* (Private Collection; repr.
Baron, 1979, pl.24). The smaller touches and the
more developed division of colour of no.22 argue
for a date slightly after the *Madeline Knox*. *The
White Jumper* (Kirkcaldy Art Gallery), which also
shows a young woman by a mantelpiece, should
equally be placed c.1911–12. Either *The White
Jumper* or *Girl by a Mantelpiece* – or a more finished
canvas similar to them – might have been the
painting shown as *The Mantelpiece* at Gilman and
Gore's 1913 exhibition (see no.15).

***23 Romney Marsh** 1911–12
Oil on board 9¾ × 14 (24·8 × 35·5)
Stamped signature lr
Exh: Colchester, 1961 (16); Reid, 1964 (8);
Colchester, 1969 (17); Sudbury, 1978 (33)
Prov: Mr and Mrs F. A. Girling
Lent from a Private Collection

The majority of Gilman's Romney Marsh pictur
would seem to date from about 1909–12. A
painting, apparently of Romney Marsh, in
Kirkcaldy Art Gallery has been appropriately
dated c.1909 by Wendy Baron (1979, p.367).
No.23 would appear to be a little later in date, d
to its brighter palette and more spontaneous
touch, and probably belongs to a group of oil
sketches of Romney Marsh including the one in
Hamilton Art Gallery, Ontario. Manson and
Lucien Pissarro worked in Rye in 1913, but
Gilman's paintings resemble more closely the oil
sketches made by Robert Bevan in Poland c.1900
such as *Morning over the Ploughed Fields* (Tate
Gallery).

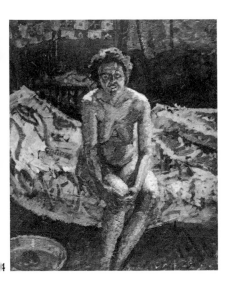

4 Nude on a Bed 1911–12
Oil 24 × 20 (61 × 50·8)
Signed lr: 'H. Gilman'
Exh: 2nd Camden Town exh., Dec 1911 (20 or
22?); Gilman/Gore, 1913 (7, 9, 21, 39?); Lefevre,
1950 (10); Arts Council, 1953 (21); Arts Council,
1954–5 (26); Columbus, Ohio, *British Art,
1890–1928*, 1971 (30)
Lit: Wood Palmer, June 1955, p.173 (repr.); *York
City Art Gallery Preview*, viii, 1955, pp.318, 322
(repr.); York City Art Gallery, *Catalogue of
Paintings*, III, 1974, p.25, repr. pl.35; Baron, 1979,
p.369; Watney, pp.60–1, repr. pl.41
Prov: Private Collection; Lefevre Gallery (by
1953); the Very Rev. E. Milner-White (purchased
1955); his gift to the present owner, 1955
Lent by York City Art Gallery

For the possibility that *Nude on a Bed* was shown
at the second Camden Town Group and
Gilman/Gore exhibitions see nos.21 and 25
respectively. Gilman's adventurous use of colour –
the bright red curtain, apparently arbitrary patches
of sharp blue, and characteristic combination of
greens and purples on the torso – would suggest
that *Nude on a Bed* was painted after no.21 and
immediately before his group of related nudes (see
no.25).

25 Nude Seated on a Bed 1911–12
Oil 24½ × 20⅛ (62·2 × 51)
Signed lr: 'H.G.'
Exh: Gilman/Gore, 1913 (7, 9, 21, 39?);
Newcastle upon Tyne, Laing Art Gallery, *Modern
Paintings and Drawings lent by Arthur Crossland,
Esq*, 1939 (221); Agnew, *British Paintings*, Nov–
Dec, 1969 (24)
Lit: *Apollo*, March, 1970, p.7
Prov: Arthur Crossland, Bradford; Piccadilly
Gallery; Sotheby 15 Nov 1978 (67); Mayor
Gallery
Lent by the Whitworth Art Gallery, University of
Manchester

This painting shows the same bed and interior as
two other canvases of similar size, *Nude on a Bed*
(Cambridge, Fitzwilliam Museum; see fig.9) and
The Model. Reclining Nude (no.26). An aggressive,
slashing handling is common to all three paintings,
and they should be seen as a group. The same
model seems to have sat for all three pictures (and
also for no.24?), as well as for the unfinished
portrait *Seated Girl in Blue* (c.1911–12; Ipswich
Museum). She could be the 'chère amie' of Gilman
who modelled for Ethel Sands in 1912, the time
when he reputedly kept a 'superfluous' woman
(Baron, 1977, pp.99, 134). Nos.24, 25, 26, the
Fitzwilliam *Nude on a Bed*, and possibly *Nude at a
Window* (Private Collection; see no.27), could each
have been among the four numbered nudes shown
at the Gilman/Gore exhibition in 1913.

***26 The Model. Reclining Nude** 1911–12
Oil 18 × 24 (45·7 × 61)
Stamped signature lr
Exh: 2nd Camden Town exh., Dec 1911 (22?);
Gilman/Gore, 1913 (7, 9, 21, 39?); Lefevre,
1943 (20); Lefevre, 1950 (9); Fine Art Society,
1976 (30, repr. p.11)
Lit: Baron, 1979, pp.146, 225, 227, 367, repr.
pl.82; *Arts Council Collection*, 1979, repr. p.106;
Watney, pp.60–1, repr. p.61; Harrison, 1981,
p.341, repr. p.39
Lent by the Arts Council of Great Britain

Baron (p.227) tentatively suggests that *The Model*
may have been *Nude No.2* at the second Camden
Town Group exhibition on the basis of a
description by a contemporary critic. The
writer's words – '*Nude No.2* – the same model with
the same imperfections less cynically exhibited' – is
made attractive by a flicker of fitful sunlight on the
undraped body' (*Daily Telegraph*, 14 December
1911) – are surely not sufficiently specific to
sustain such an identification. Given Gilman's
interest in the '*Rokeby*' *Venus* ('The Venus of

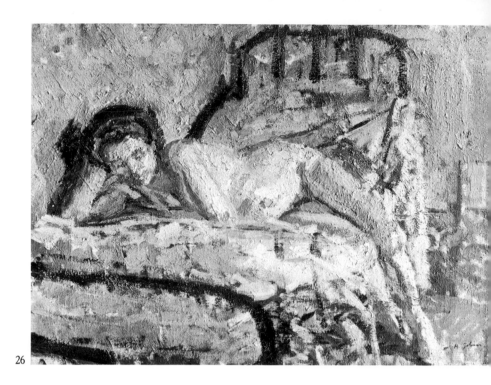

26

27

28

Velasquez', *Art News*, 28 April 1910, p.198) it may be worthy of note that although *The Model* faces the spectator, her torso, head and arms are arranged in a similar fashion to Velasquez's nude. Another reclining *Nude on a Bed* is in the possession of the artist's family.

Woman Combing her Hair 1912?

Oil 24× 18 (61× 46·5)
Signed lr: 'H. Gilman'
Exh: Brighton, 1913 (39); Gilman/Ginner, 1914 (2); Leicester Galleries, 1919 (33); Arts Council, 1954–5 (18); Reid, 1964 (12); Agnew, *British Painting, 1900–6,* 1968 (14); Colchester, 1969 (25, repr.); Fine Art Society, 1976 (36); Mellon Centre, 1980 (32, repr.)
Lit: D. Farr, *Burl. Mag,* June 1955, p.184; Baron, 1979, p.366
Prov: The artist's family; Agnew; to present owner, 1968
Lent by the Royal Albert Memorial Museum, Exeter

Woman Combing her Hair is related to *Nude at a Window* (1912?; Private Collection); they share the same setting of window and sofa and may have been posed by the same model.

Study for Woman Combing her Hair 1912?

Chalk, pen and ink 12× 9 (30·5× 22·9)
Signed lr: 'H. Gilman' Annotated
Exh: Leicester Galleries, Sept 1948 (12 or 17? both drawings entitled *Woman Combing her Hair*); Arts Council, 1954–5 (44, repr.); Arts Council, 1961–2 (22); Fine Art Society, 1976 (37); Mellon Centre, 1980 (33, repr.)
Lit: Bevan, 1946, pp.55–6, repr. p.56; *Arts Council Collection,* London, 1979, p.106, repr.
Prov: Sir Louis Fergusson (gift of the artist); Leicester Galleries to the present owners, 1948
Lent by the Arts Council of Great Britain

This fascinating sheet, its mixed media indicative of Gilman's increasing preference for pen rather than chalk in his graphic work, was a working drawing for the painting (no.27). An unsigned drawing of the same size (Reid, 1964, 47), entitled *Girl Combing her Hair,* is probably a related study. Bevan (p.55) records that the artist considered no.28 one of his best drawings, and gave it to Fergusson.

29 A Woman Washing 1912?

Pen, ink and charcoal 10¼× 7¾ (26× 19·7)
Unsigned
Exh: Reid, 1964 (50)
Prov: John Gilman
Lent by the University of Leeds

No.29, the *Nude Drying Herself* (Oxford, Ashmolean Museum) and a sheet entitled *Ablutions* (formerly Louis Fergusson, Leicester Galleries, September 1948, 20) are the only known drawings by Gilman of the washing motif. The *scène de toilette,* no doubt derived from the examples of Degas, Toulouse-Lautrec and other continental predecessors, was more frequently treated by Sickert (see fig.1) and Gore.

*30 The Café Royal 1912

Oil 29¼× 24½ (74·3× 62·2)
Signed and dated lr: 'H. Gilman 1912'
Exh: Gilman/Gore, 1913 (5 or 40); Colchester, 1969 (19); Anthony d'Offay, *Paintings of London by Members of the Camden Town Group,* Oct–Nov 1979 (12)
Lit: Lewis and Fergusson, p.27; Baron, 1979, pp.42, 49, 233, 286, repr. pl.109.
Prov: C. Fort Franques, Cardiff
Lent by Mr and Mrs Evelyn Joll

Two paintings entitled *The Café Royal* were exhibited in 1913, one on sale at 20 and the other at 40 guineas; it is not known whether the present canvas was no.5 or no.40. Gilman frequented the Café Royal in the years before the war, as Oliver Brown remembered: 'The Camden Town Group was often in evidence – Gilman, Ginner, Bevan, Spencer Gore sometimes . . .' (*Exhibition. The Memoirs of Oliver Brown,* London, 1968, p.45. See also Ashley Dukes, *The Scene Is Changed,* 1942, p.41. Gilman was also an *habitué* of the Restaurant de la Tour Eiffel: Augustus John, *Chiaroscuro,* 1952, p.136). Paintings of the Café Royal had been produced by Ginner in 1911 (fig.4) and Orpen the following year (Paris, Palais de Tokyo). For Gilman's use of a grid, visible in this canvas, see no.49.

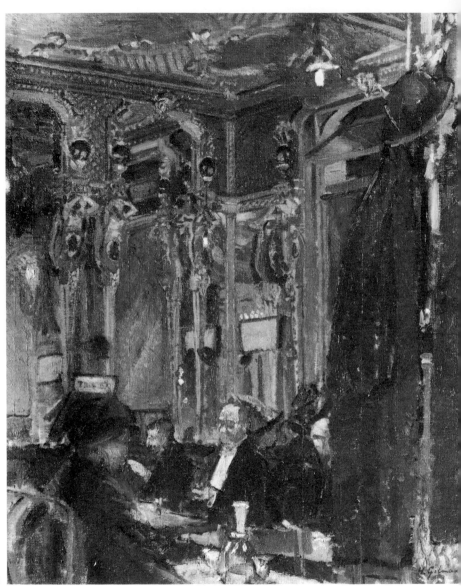

30

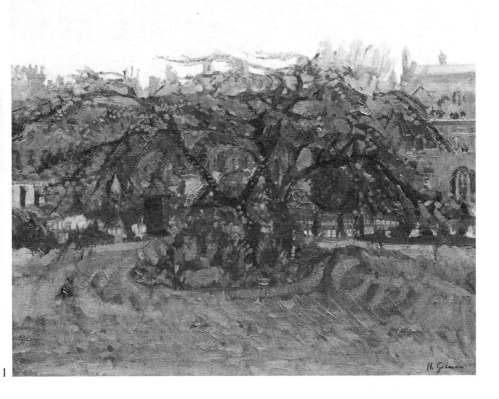

1

1 Clarence Gardens NW 1912
Oil 20 × 24 (50·8 × 60·1)
Signed lr: 'H. Gilman'
Exh: Gilman/Gore, 1913 (18); Gilman/Ginner, 1914 (18); Leicester Galleries, 1919 (11); Lefevre, 1943 (7, as *Mornington Crescent*); Camden Arts Centre, *The Camden Scene*, Feb 1979 (103); Dundee Art Gallery, *English Paintings 1900–1950*, 1979 (12)
Lit: Lewis and Fergusson, p.30; Baron, 1979, pp.27, 322, 367; Watney, p.68, repr. pl.58
Prov: Major R. A. Hornby; Leicester Galleries to the present owners, 1975
Lent by the Ferens Art Gallery, Kingston upon Hull

Two versions of this picture exist; the other is smaller (London, Odin's Restaurant). Both were shown in the 1913 and 1914 exhibitions, and can be distinguished in the catalogue by the higher prices presumably attached to the larger picture on each occasion. The small number of outdoor London scenes by Gilman from this period includes these, the slightly earlier *B.D.V.*

Hampstead Road (Private Collection), and *Mornington Crescent* (1912?) in the National Museum of Wales. No.31 is a very similar view, focusing on the same tree, to a composition made at the same time by William Ratcliffe, with whom Gilman visited Sweden in the summer of 1912, probably very soon after this painting was made.

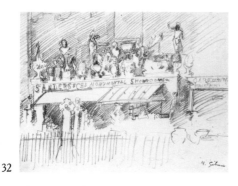

32

***32 Monumental Mason's Shopfront** 1912?
Pencil 8¾ × 12 (22·5 × 30·5)
Stamped signature lr
Prov: the artist's family
Lent by the artist's family

The date is suggested by the use of pencil. Later
drawings of the urban scene, such as *Cumberland
Market* (c.1915; repr. Wood Palmer, 1964, p.249)
and the *Leeds Factory* sheets (1915, nos.57–9),
tend to be in pen and ink. A slightly larger oil
sketch, showing shopfronts and awnings, can also
be dated about 1912 (artist's family). The subject of
the shopfront recalls earlier paintings by Whistler
and Sickert.

33 An Orchard 1912?
Pencil; squared 17¾ × 16¼ (45·1 × 41·3)
Unsigned
Exh: Newcastle, 1974 (20)
Prov: Christie, April 1962
Lent by the University of Newcastle upon Tyne

This large, finished pencil drawing, heavily
inscribed with colour notes and squared for
transfer, seems to be unique in Gilman's work and
is difficult to date. Gilman does not appear to have
used the squaring technique, which he acquired
from Sickert, before 1912. The colour notes, such
as 'tiles purplish slate', 'line of red bricks', and (in
the sky area) 'pale blue merging into mauve',
though they are not firm evidence of what an oil
painting based on the drawing might have looked
like, are characteristic colours of Gilman's painting
in and just after 1912. It is possible, therefore, that
this drawing may be associated with the untraced
Apple Tree, Sweden, which was first shown at the
Gilman/Gore exhibition in January 1913 (9).

34 Porch, Sweden(?) 1912?
Oil 20 × 16 (50·8 × 40·7)
Signed lr: 'H. Gilman'
Exh: 3rd Camden Town exh., December 1912 (19
this title); Gilman/Gore, 1913 (20 this title)
Lit: *The Times*, December 19, 1912; Baron 1979,
p.308
Prov: Wyndham T. Vint
Lent by the Vint Trust

This picture has generally been known as *Street
Scene in Norway*, and is very similar to a painting
known as *Norway* sold from the Gilman family
collection at Christie's, 13 March 1974. But both
pictures are clearly a view from a slightly different
angle of the verandah in *The Verandah, Sweden*
(no.40 here), and it thus seems likely that either
this or the picture sold at Christie's should be
identified with the otherwise unknown *Porch,
Sweden*.

 Judged by the number and quality of pictures
that resulted, Gilman's Swedish trip of 1912 was a
success. Three Swedish paintings were shown at
the last Camden Town show in December 1912,
Porch, Sweden; *Kyrksjön, Gladhammar, Sweden*;
and *The Reapers, Sweden* (no.35 here). Four more
Swedish pictures, in addition to *The Reapers* and
Kyrksjön, were shown at the Gilman/Gore
exhibition at the Carfax in January 1913: *Interior,
Sweden*, which could possibly be no.36 here; *The
Valley, Gladhammar, Sweden*; *Verandah, Sweden*
(no.40 here), and *The Apple Tree, Sweden*
(see no.33).

 A Swedish Landscape was shown at the
Contemporary Art Society's first London
exhibition in April 1913, and may have been the
picture known as *Open Landscape with Winding
Fence*, sold Sotheby's in Toronto, 31 March 1981
(144), with a Contemporary Art Society's
exhibition label on the back; alternatively it may be
no.40 here.

 A Swedish Village (39) seems not to have been
exhibited in Gilman's lifetime unless it was
Kyrksjön, see above. In exhibitions after Gilman's
death titles occur, such as *Swedish Lake* at the 1943
Lefevre show, which may be pictures shown
earlier under different titles, or even Norwegian
subjects.

†35 The Reapers, Sweden 1912
Oil 20 × 24 (51·0 × 61·0)
Signed lr: 'H. Gilman'
Exh: 3rd Camden Town exh., December 1912
(20); Gilman/Gore, 1913 (11)
Lit: *Athenaeum*, 18 Jan 1913, p.35; Baron
1979, pp.42, 215, 304, 308, 370, repr. pl.122.

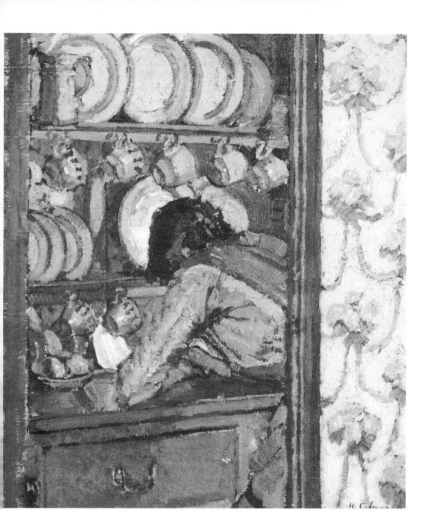

Prov: Sylvia Gosse; her gift to the present owner 1913
Lent by Johannesburg Art Gallery

This is the only Gilman picture to have entered a public collection in his lifetime, if his Canadian War Records Commission (nos.96–105) is excepted. Sylvia Gosse (for whom see also the note to 47), was the daughter of the writer Edmund Gosse, a friend of Robert Ross who had been until 1908 a director of the Carfax Gallery, and was appointed in 1912 London adviser to Johannesburg Art Gallery; this may help to account for the acquisition of the painting by Johannesburg.

See note to 34

***36 The Shopping List** 1912?
Oil 23¼ × 19¼ (61·5 × 51·0)
Signed lr: 'H. Gilman'
Exh: possibly Gilman/Gore, 1913 (19 as *Interior Sweden*, or 42 as *The Pantry*)
Prov: the present owner from the Lefevre Gallery 1948.
Lent by The British Council

See note to 34

38

37 The Shopping List 1912?
Ink over black chalk; squared 9½ × 8 (24·2× 20·4)
Signed on the verso: 'H. Gilman'
Exh: Lefevre 1948 (12); Arts Council 1954–5 (47);
Reid, 1964(90)
Prov: the present owner from the Reid Gallery
1964 (Emanuel Fund)
Lent by the Visitors of the Ashmolean Museum,
Oxford

Study for 36

***38 Swedish Landscape** 1912?
Oil 20× 35 (50·8× 89)
Signed lr: 'H. Gilman'
Exh: ? Contemporary Art Society 'First Public
Exhibition in London'; Goupil, April, 1913 (118);?
Gilman/Ginner, 1914 (25); ? Cumberland Market
Group, 1915 (28); Lefevre, 1943 (16 repr.);
Lefevre, 1948 (17); Lefevre, 1950 (11); Arts
Council, 1954–5 (19); Reid, 1964 (14); Colchester,
1969 (22); Colchester, July 1975 (63)
Prov: R. A. Bevan
Lent from a Private Collection

This picture has been assumed to be the *Swedish
Landscape* exhibited during the artist's lifetime.
But the painting at the Gilman/Ginner exhibition
was priced at £18, which would have been too
little for this much larger than average canvas, and
that picture may well have been the one known as
Open Landscape with Winding Fence (see note to
34).

39 A Swedish Village 1912
Oil 16⅛ × 20¼ (40·9× 51·2)
Signed ll: 'H. Gilman'
Exh: Arts Council, 1954–5 (21)
Prov: Christie June 22, 1962 as *Red Houses,
Swedish Village*; the present owner from the Leger
Galleries 1963
Lent by the National Gallery of Canada, Ottawa

See note to 34

***40 The Verandah, Sweden** 1912
Oil 20× 16 (50·8× 40·6)
Signed lr: 'H. Gilman'
Exh: Gilman/Gore, 1913 (8); Doré Gallery, 191
(50); ? Gilman/Ginner, 1914 (20 or 29);
Cumberland Market Group, 1915 (28); Lefevre,
1950 (8); Univ. of New Brunswick, *The
Beaverbrook Collection*, Nov 1954 (14); Univ. of
New Brunswick *Paintings by Old and Modern
Masters*, Oct–Nov 1955 (94)
Lit: *Beaverbrook Art Gallery. Paintings* 1959 p.4
Baron; 1979, pp.130, 369–70; Baron and Cormac
pp.17–18
Prov: Rex de C. Nan Kivell; Lord Beaverbrook
(by 1954)
Lent by the Beaverbrook Art Gallery, Frederict

The pictures shown at the 1914 exhibition were
Swedish Verandah No.1 and *No.2*; these could h
been no.34 here and the picture known as *Norwo*
(see note to 34), which are extremely similar, or
one of those and this one, which appears to show
the same porch from a slightly different angle.
 This picture appears on the easel in the
background of Malcolm Drummond's painting
19 Fitzroy Street (repr. Baron 1979 pl.18).

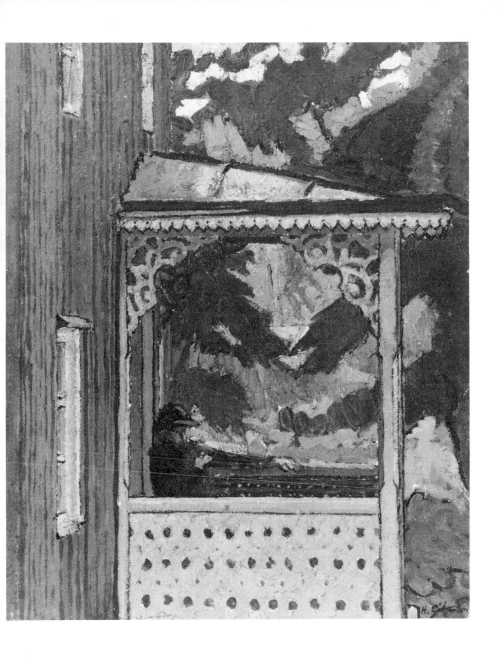

61

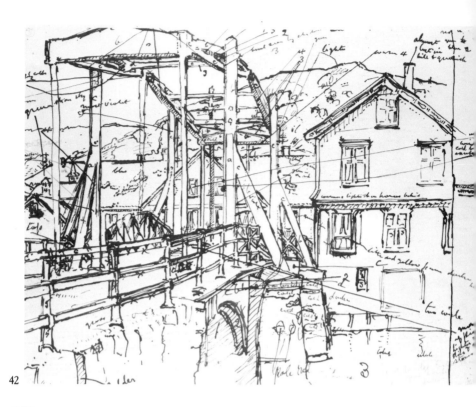

42

41 The Canal Bridge, Flekkefjord 1913
Oil 18 × 24 (45·7 × 65·0)
Signed lr: 'H. Gilman'
Exh: Doré Gallery, 1913 (52 as *A Bridge in
Norway*), and Cumberland Market Group, 1915
(6 as *A Bridge, Norway*), unless these were no.
44; London Group, March 1915 as *Flekkefjord*
(26); Arts Council 1954–5 (ex cat.); Colchester
1969 (20 repr.)
Lit: Rutter, *Sunday Times* 21 March 1915; Farr,
Burl. Mag, June 1955, p.184; *Tate Gallery
Modern British Paintings* . . . vol.1, 1964,
pp.234–5, repr. pl.IV in colour; Baron 1979,
pp.288, 332, 368; Watney repr. pl.40
Prov: Walter Taylor from the London Group,
1915; the present owner 1922
Lent by the Trustees of the Tate Gallery, London

The first owner Walter Taylor was a watercolourist
and co-exhibitor with Gilman at the London
Group. This was the first picture by Gilman to
enter a British public collection.

As with Gilman's visit to Sweden in 1912, so his
Norwegian trip in 1913 was productive in terms of
pictures. The first picture to be shown was
Norwegian Interior at the Goupil Salon, autumn

1913. Either 41 or 44 here was shown in October
1913 at the Doré Gallery's 'Post-Impressionist a
Futurist' exhibition. *Norway* and *Norwegian
Landscape* were shown at the Gilman/Ginner
exhibition in 1914; the first may be the landscape
sold by the Gilman family at Christie's in 1974 (s
note to 34), while the second may be *The
Washerwoman*, sold by Boisgirard at the Hôtel
Drouot, Paris, June 5, 1970. At the NEAC in 191
Gilman showed *Norwegian Fjord* which is proba
the picture now known as *Lake in the Hills*
(Auckland Art Gallery, New Zealand), but could
also be an otherwise unidentified canvas known a
The Lake (Tatham Art Gallery, Pietermaritzburg
At the second London Group show in autumn 19
Gilman showed *Norwegian Waterfall* (Western
Australian Art Gallery, Perth), the history of wh
is difficult to disentangle from that of 41. At the
Goupil Salon in autumn 1914 Gilman showed
Kirkogaten, Flekkefjord, Norway, which is not no
known.

The Canal Bridge, Flekkefjord 1913
Ink 9× 11½ (23·0× 29·0)
Unsigned
Exh: Arts Council, 1954–5 (ex cat., Tate showing only)
Lit: Watney, p.66
Prov: the present owner from Sylvia Gilman 1955
Lent by the Trustees of the Tate Gallery, London

Study for 41

Landscape in Norway 1913
Ink and watercolour; squared in red pencil
11½× 18 (29·0× 45·4)
Signed lr: 'H. Gilman'
Exh: Reid, 1964 (58)
Lent by the artist's family

***44 The Mountain Bridge** 1913
Oil 24× 31 (61·0× 78·7)
Signed lr: 'Harold Gilman'
Exh: Doré Gallery, 1913 (52 as *A Bridge in Norway*) and Cumberland Market Group, 1915 (6 as *A Bridge, Norway*), if these were not no. 41; Gilman/Ginner, 1914 (40); Colchester, 1969 (21)
Lit: Baron 1979, pp.288, 332, 368, 369
Prov: Hugh Blaker; Jenny Blaker, his sister; her gift to the present owner in memory of her brother, 1945
Lent by Worthing Museum and Art Gallery

Hugh Blaker (1873–1936) was born in Worthing. After studying painting in Antwerp and Paris he was appointed curator at the Holburne of Menstrie Museum, Bath in 1905. In 1913 he came into some money and retired, establishing himself as a picture dealer of considerable discrimination. The monument to his taste is the Davies Collection, now in the National Museum of Wales, which Blaker did much to form. With Louis Fergusson and Walter Taylor, Blaker was one of Gilman's most important patrons, buying a number of canvases in the 1910s, including nos.19 and 44.

63

†45 Mrs Robert Bevan 1913?
Oil 24× 20 (61·0× 50·8)
Unsigned
Exh: ? Leicester Galleries, 1919 (38); ? Tooth,
1934 (4); Lefevre, 1943 (19); Arts Council, 1954–5
(41); Colchester, 1961 (17); Reid, 1964 (35);
Colchester, 1969 (45); Colchester, 1975 (69)
Prov: R. A. Bevan, 1947
Lent from a Private Collection

This is one of three oil portraits Gilman made of
the painter Stanislawa de Karlowska, the
Polish-born wife of his friend, the painter Robert
Bevan. All three were acquired on the art market at
different times after the artist's death by the sitter's
son-in-law, R. A. Bevan. The others have generally
been dated c.1911, c.1912–4, and this one 1918 or
c.1918. In support of a late date for this portrait is
an ink sketch of the sitter (11⅛× 9⅛) repr. *Alphabet
and Image*, December 1946 and given the date
1917 when shown at the Reid exhibition (73) in
1964. It is a profile drawing similar, but not
identical, to this painting in pose.
 On the other hand neither the rich colour of the
background nor the open, fluid handling of the
paint is in keeping with Gilman's very late style of
portraiture in which the handling, as in 90, tends
to be tightly constructed in smaller strokes and the
contours are liable to be closed with a bounding
line. A date of 1913, when other portraits, such as
46 and 47, show that Gilman's handling of paint
and colour were becoming increasingly bold, is
tentatively suggested.

46 Portrait of a Man 1913?
Oil 22× 17½ (57·8× 44·5)
Stamped signature ll
Exh: Reid, 1964 (31); Colchester, 1969 (33)
Lit: Baron 1979, p.366
Prov: Sir John Rothenstein; the present owner 1964
Lent by Bradford Art Galleries and Museums

The early history of the picture is unknown,
though it could be the *Portrait* shown at the first
London Group exhibition in March 1914.
 This has been thought to be Bernhard Sickert,
(1862 or 3–1932) younger brother of Walter
Sickert. Bernhard Sickert showed with the NEAC,
and at the AAA in 1912 and 1913. He published a
biography of Whistler in 1908.

***47 Sylvia Gosse** 1913?
Oil 27× 20 (68·6× 50·8)
Signed lr: 'H. Gilman'
Exh: Goupil Autumn Salon, 1913 (103); ? Londc
Group, March 1914 (92); Gilman/Ginner, 1914
(4 or 24); ? Leicester Galleries, 1919 (14);
Lefevre, 1948 (27); Lefevre, 1950 (12);
Southampton, 1951 (27); *Decade 1910–1920*, 196
(43); Colchester, 1969 (28); Plymouth, 1974 (7);
Newcastle, 1974 (17); Hastings Art Gallery,
Sylvia Gosse, Painter and Etcher, May 1978 (68)
Lit: Sir C. Phillips, *Daily Telegraph*, 10 March
1914; Wyndham Lewis, *The Listener*, 11
November 1950; Baron, 1979, pp.368–9; Watney
p.128, repr. pl.25 in colour
Prov: present owner from Lefevre, 1950
Lent by Southampton Art Gallery

This is slightly the larger of two paintings of the
sitter which, she recalled, 'were painted between
1912 and 1914 at Rowlandson House where
Sickert and I had a school of painting and etchin
it closed down when war was declared.' (Letter t
the director of Southampton Art Gallery, 9 May
1951.)
 Sylvia Gosse studied under Sickert at the
Westminster Institute from c.1908, and in 1910
succeeded Madeline Knox (see note to no.18) as
co-principal with Sickert of Rowlandson House a
140 Hampstead Road. She was an exhibitor at th
AAA from 1908 and with the London Group fro
1914.
 The smaller version, 24× 20, was sold at
Sotheby's, 21 November 1962 lot 104.

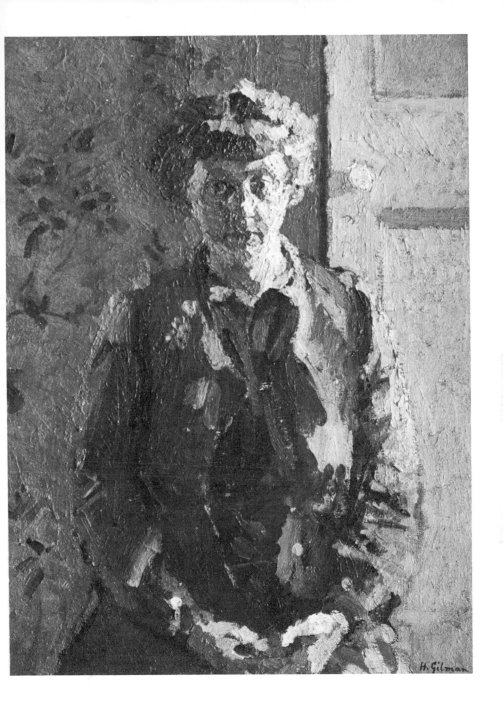

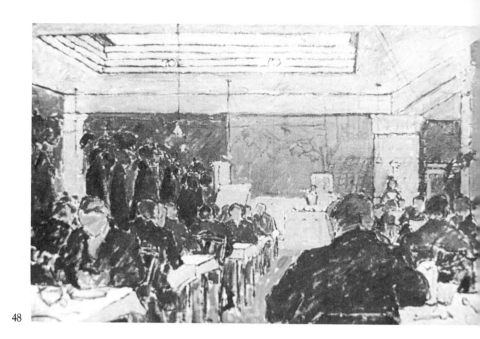

48

49

An Eating House 1913–14
Oil 36¼ × 24¼ (92·1 × 61·5)
Unsigned
Lit: Baron, 1979, p.286
Prov: the artist's family
Lent by the artist's family

This large unfinished canvas probably preceded
the two more ambitiously designed pictures of a
similar motif (see no.49). We know from Marjorie
Lilly (*Sickert*, 1971, p.130) that Gilman made
great efforts to study Van Gogh's paintings in the
original and he must have seen *Interior of a
Restaurant in Arles* (1888; Providence, Danforth
Collection; de la Faille 549) – then in a London
private collection – which no.48 resembles.
Ginner (Memorial Exhibition cat., 1919, p.5)
recalled that Gilman 'delighted in painting the
poorer classes, the natives of Camden Town and
their humble interiors'. This comment would
seem somewhat difficult to support on the
evidence of existing pictures. Although Gilman's
politics were certainly Socialist, his subjects were
predominantly middle-class in orientation. The
Eating House paintings and the earlier nudes are
among the few works that uphold Ginner's
contention.

An Eating House 1913–14
Oil 17½ × 23½ (44·4 × 52·7)
Signed lr: 'H. Gilman'
Exh: Gilman/Ginner, 1914 (37); London Group,
March, 1914 (29 or 93); Cumberland Market
Group, 1915 (49); Arts Council, 1954–5 (25);
Royal Academy, 1963 (105); London Group
Jubilee Exhibition, 1964 (14); Agnew, *English
Pictures from Suffolk Collections*, February 1980
(16)
Lit: Sir C. Phillips, *Daily Telegraph*, 10 March
1914; Rutter 1930; Rothenstein, 1952, p.154; Bell,
Motif, 1963–4, p.81 (repr.); Fairfax Hall, 1965,
repr. pl.7; Baron, 1979, pp.286, 340; Watney,
pp.66, 68
Prov: Mrs Alec Keiller 1915; Edward Le Bas RA
Lent by Richard Burrows

A similar, slightly larger version, 22½ × 29½,
belongs to Sheffield City Art Galleries (formerly
coll: Walter Taylor; Watney, repr. col. pl.23). The
Sheffield version is one of a small number of
instances where a pair of near-identical
pictures bears marks of a grid having been imposed
on the surface when the paint was still wet,
suggesting that Gilman used some squared device
to lift the design off the first version to start the
second. Very similar grid marks can be seen on
certain canvases of the Italian painter Mancini

whose works were known in England at the time.
What is curious in this instance is that the version
with the grid marks, which was reproduced in the
Gilman/Ginner catalogue, was there described as
'No. 2', while the version exhibited here, without
the marks, was 'No. 1', which possibly suggests an
error on Gilman's part.

***50 The Coral Necklace** 1914
Oil 24 × 18 (61·0 × 45·7)
Signed and dated ll: 'H. Gilman 1914'
Exh: Gilman/Ginner, 1914 (40); NEAC, Summer
1914 (269); Cumberland Market Group, 1915 (43);
Tooth, 1934 (20); Lefevre, 1943 (13); Royal
Academy, 1963 (91); Norwich, *A Terrific Thing*
1976 (26)
Lit: *The Times* review of NEAC 1914; *Sunday
Times* review of NEAC 1914; Lewis and Fergusson
repr. p.69; Fairfax Hall, 1965, repr. pl.4 in colour;
Baron, 1979 pp.69, 168, 334, 345, 366, repr. pl.133
Prov: J. Alford 1915; Edward Le Bas RA 1943 or
after; the present owner 1969
Lent by The Royal Pavilion, Art Gallery and
Museums, Brighton

The depiction of a specific gesture in this painting
is unusual. Baron identifies the sitter as Mary L;
see note to 51.

†51 Girl with a Teacup 1914?
Oil 24½ × 20¼ (62·2 × 52·1)
Signed lr: 'H. Gilman'
Exh: ? Gilman/Ginner, 1914 (28 or 41 as *Mary L*);
Redfern, 1939 (36, repr. cat. cover); Lefevre, 1943
(4? as *Portrait of a Girl* lent by Edward Le Bas);
Arts Council, 1954–5 (28); Royal Academy, 1963
(163); Agnew, *British Painting*, October 1975 (18)
Lit: Wood Palmer 1954, p.5; Wood Palmer,
Edward Le Bas, Patron of English Art, April 1963,
repr. in colour; Quentin Bell, *Motif*, Winter 1963–4
p.82 and repr.; Fairfax Hall, 1965, p.47 and repr.
pl.8; Baron, 1979, p.168; Royal Academy, 1979,
p.192
Prov: Murray Urquhart; Edward Le Bas RA;
B. Fairfax Hall
Lent from a Private Collection

Traditionally believed to be a portrait of an
Austrian friend of the painter, Mary L. Gilman
portraits at the Gilman/Ginner 1914 exhibition
included *Mary* (no.28, £25) *Mary Z* (a misprint
for *Mary L*?) (no.41, £25), and *Marie* (no.17,
£10). Numbers 28 and 41 may be this picture and
Portrait in Profile, Mary L (formerly Le Bas
collection, now Private Collection, Australia),
which is the same size. No.17, at the lower price,

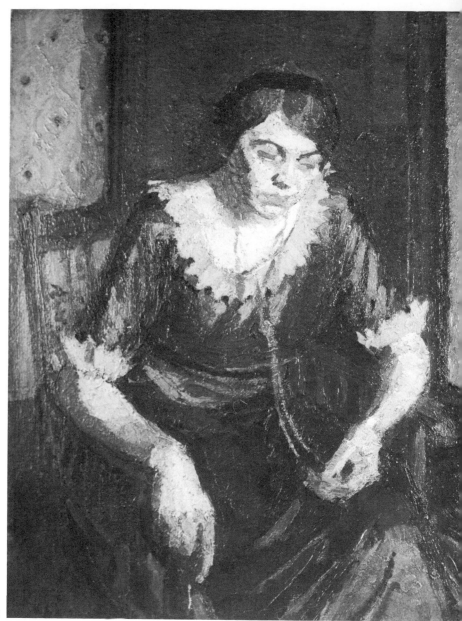

50

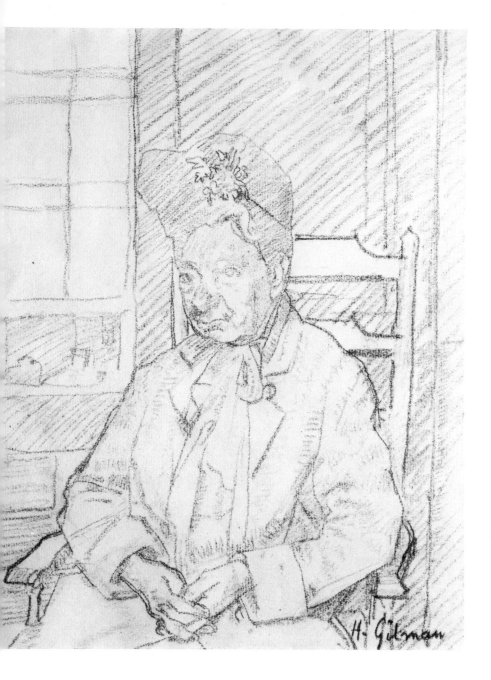

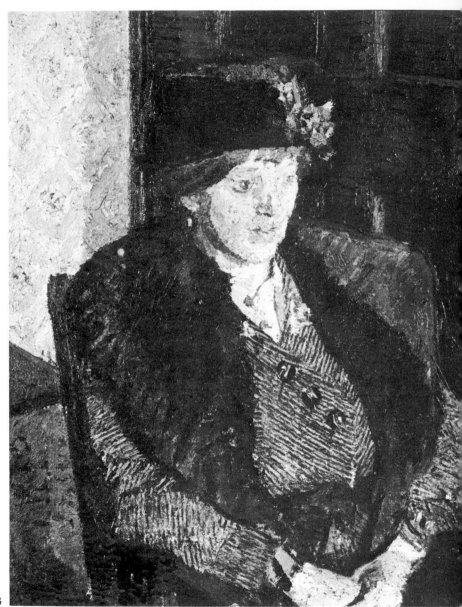

53

may have been *Contemplation, Mary L* (formerly Frank Girling collection, now Glasgow Art Gallery) which is 14× 12; it is very similar to, and probably an earlier version of, *Girl with a Teacup*, lacking the teacup and the clock on the wall. The painting hanging on the wall to the upper left is Ginner's *The Wild Ducks* (1911–12) which Gilman owned. Drawings related to *Girl with a Teacup* are in the British Museum and the Cecil Higgins Art Gallery, Bedford.

Mrs Mounter in a Hat 1914?
Black chalk 12× 9 (30·5× 22·9)
Signed lr: 'H. Gilman'
Exh: Lefevre, 1948 (18); Arts Council, 1954–5 (51); Royal Academy, 1963 (216); Reid, 1964 (75); Hampstead Festival, 1965 (18)
Lit: Fairfax Hall, 1965, repr. pl. 8
Prov: Edward Le Bas RA from Lefevre 1948; the present owner 1978
Lent from a Private Collection

The sitter was Gilman's landlady when he lived at 47 Maple Street off Tottenham Court Road between 1914 and 1917. Dated 1916 when shown in 1954–5, this drawing has been associated with the paintings of the sitter (see 76). But the drawing style here is very different and suggests an earlier date.

Mrs Victor Sly 1914–5
Oil 20¼× 16⅓ (51·5× 42·0)
Unsigned
Exh: London Group, March 1915 (74); Cumberland Market Group, 1915 (15); Leicester Galleries, 1919 (16); Southampton, 1951 (31)
Lit: Lewis and Fergusson repr. p.95; Baron, 1979 p.365
Prov: the present owner 1938
Lent by Wakefield Art Gallery and Museums

Dora Sly was, according to Marjorie Lilly (*Sickert, the Painter and his Circle* 1971, pp.95–7), 'a young woman with an attractive Danish accent and a part-time husband who lived at the Piccadilly Hotel . . . (and) was suspected of being involved in a gambling club in the west end.' She lived at 8 Fitzroy Street and was friendly with many of the Fitzroy Street group; she sat for them, and they helped her when she was in financial difficulties.

54

*54 **Interior** 1915?
Oil 17× 11 (43·2× 27·9)
Signed lr: 'H. Gilman'
Prov: Sotheby 27 June 1979
Lent from a Private Collection

A painting of this title, not otherwise identified, was shown at the London Group, November 1915 (19); it may have been this picture or possibly *Interior with a Washstand* (Art Gallery of South Australia). One of the very few of Gilman's books still remaining in the family is a portfolio of large-sized reproductions of pictures by Van Gogh (*Van Gogh-Mappe*, Munich, 1912), which includes *Vincent's Chair with his Pipe* of 1888 (de la Faille 498; Tate Gallery), the image that may have given Gilman the idea for this painting. *Interior* depicts Gilman's rooms at 47 Maple Street, and the painting hanging on the wall in the centre is Ginner's *The Wild Ducks* (see no.51).

55

***55 The Lane** 1915
Oil 20 × 16 (49·4 × 39·4)
Signed lr: 'H. Gilman'
Exh: Leicester Galleries, 1919 (22); Tooth, 1934
(11); Lefevre, 1950 (18); Southampton, 1951 (29);
Arts Council, 1954–5 (31); Colchester, 1969 (36);
Plymouth, 1974 (53)
Lit: Nicolson, *Burl. Mag*, September 1951; Wood
Palmer, *Studio*, June 1955, repr.
Prov: the present owner 1955
Lent by Plymouth City Museum and Art Gallery

Exhibited in 1919 under this title, in 1934 as *A
Staffordshire Lane*, and in subsequent exhibitions
to 1954–5 wrongly described as Gloucestershire. In
fact made when Gilman was staying with the
painter Hubert Wellington at Walton-on-the-Hill
near Stafford.
 Two associated drawings are known, one no.56
here, the other in black ink, 11½ × 9, repr.
Connoisseur April 1964, exh: Colchester 1969 (51)
and sold Sotheby's 4 June 1971.

56 The Lane 1915
Ink over brown chalk; squared 11½ × 9
(29·2 × 22·9)
Signed lr: 'Gilman'
Exh: probably Arts Council, 1954–5 (49); Reid,
1964 (66 as *House and Lane*)
Prov: present owner from Reid 1964
Lent by Plymouth City Museum and Art Gallery

Study for 55

57 Leeds Factories II 1915
Black ink with pencil 10½ × 18¼ (27·0 × 46·3)
Stamped signature lr
Exh: probably Arts Council, 1954–5 (46)
Lent by the Victoria and Albert Museum, London

The factory building on the left is Millgarth Mill
and the building on the right is the Model Lodging
House; both have since been demolished.
 The drawing of this title and size lent by Sylvia
Gilman to the 1954–5 exhibition was given the
date 1913. But the style of the Leeds factory
drawings, the use of Indian ink and the extensive
spotting, associates them with Gilman's late
drawing style for which 1913 seems too early.
 Frank Rutter, appointed director of Leeds City
Art Gallery in 1912, said that the oil painting
Leeds Market resulted from a trip Gilman made
with Ginner to Leeds in 1913. This date is also
rejected (see note to 61), and though it is likely
enough that Gilman, who had known Rutter well
since 1907, did visit him in Leeds in 1913, it is
suggested below that there are reasons for dating
Leeds Market 1915, and these cast some doubt on
Rutter's testimony as a whole.

58 Leeds Factories 1915
Ink 9 × 11½ (23·1 × 29·2)
Unsigned
Exh: Lefevre, 1948 (9)
Lent by the Victoria and Albert Museum, London

59 Leeds Factory 1915
Ink, pencil with red chalk 9⅝ × 14 (24·5 × 35·5)
Unsigned
Lent by the artist's family

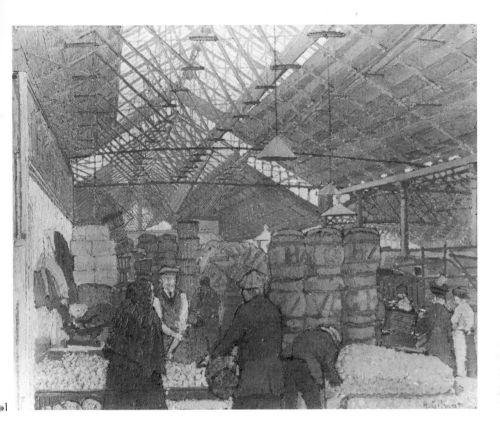

1

50 Steeple, Leeds 1915
Ink 9⅜ × 4⅜ (23·8 × 15·5)
Unsigned. Verso: another study of the steeple
Lent by the artist's family

The drawing is a detail of part of the left hand side
of no.57.

51 Leeds Market 1915
Oil 20 × 24 (50·8 × 61·0)
Signed lr: 'H. Gilman'
Exh: London Group, November 1915 (61); Arts
Council, 1954–5 (23); London Group Jubilee
Exhibition, 1964 (15 repr.)
Lit: Rutter, *Sunday Times*, 28 November 1915;
Anon. (W. Bayes), *Athenaeum*, 4 December
1915 p.424; P. G. Konody, *Observer*, 28
November 1915; Sickert, *Burl. Mag*, January 1916,
p.164; O. R. Drey, *Westminster Gazette*, 1
December 1915; Lewis and Fergusson, repr. p.71;
Rutter, 1922 p.134; Chamot 1937 p.46;
Sausmarez, *Leeds Art Calendar*, 1950 p.18; Farr,
1955, p.184, repr. p.189; *Tate Gallery Modern
British Paintings . . .* Vol.1, 1964, p.235; Farr, 1978
pp.206–7, repr. pl.75A; Baron 1979 pp.221, 368;
Watney, pp.66, 112, 118, repr. pl.22; Harrison,
1981, repr. p.44
Prov: Walter Taylor; the Very Rev. E. Milner
White by 1923; the present owner 1927
Lent by the Trustees of the Tate Gallery, London

Frank Rutter said that this picture resulted from a
trip by Gilman and Ginner to Leeds in 1913 (see
also note to no.57). Though it is not a typical
Gilman work, the dry use of paint is much more
characteristic of 1915 than the earlier date, and the
subject appears to be influenced by Ginner's
paintings such as the 1914 *Fruit Stall, King's
Cross*. It would not have been characteristic of
Gilman to have shown a two-year-old painting at
the November 1915 London Group. As it
happened this painting and Ginner's new Leeds
paintings, *The Timber Yard, Leeds* and *Crown
Point, Leeds* were among those most discussed by
the critics.
No.62 is the finished working drawing.

73

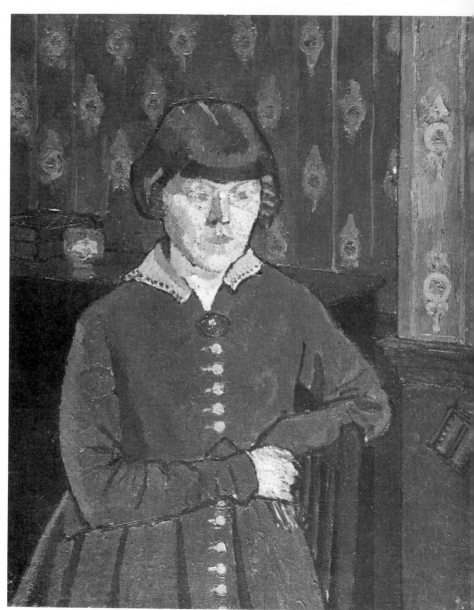

63

2 Leeds Market 1915
Ink 9⅞ × 11¾ (25·1 × 29·8)
Signed lr: 'H. Gilman'
Exh: Louis Fergusson coll., Leicester Galleries,
1948 (14); Arts Council, 1961-2 (23)
Lit: R. A. Bevan 1946, p.53; Sausmarez, *Leeds Art
Calendar*, Spring 1950, p.18; Watney, repr. pl.105
Prov: Louis Fergusson 1916; the present owner
from Leger Galleries 1957
Lent by the Trustees of the Tate Gallery, London

3 Ruth Doggett 1915?
Oil 18 × 24 (45·7 × 61)
Unsigned
Prov: the artist's family
Lent by the artist's family

Two paintings of Ruth Doggett and a drawing
(11¾ × 9, exh: Reid 1964 (61)) are known. The
other painting, repr. Lewis and Fergusson p.83,
shows her full-length seated in a chair, and was
first owned by Walter Taylor. During the artist's
lifetime he showed a Ruth Doggett portrait at the
London Group in March 1915 (73) and at the
Cumberland Market Group in April 1915 (30).
These could be either picture, but as no other
instance is known of Gilman exhibiting an
unsigned oil painting, it is likely that these too
refer to the other version.

Ruth Doggett was a painting student of both
Sickert and Gilman. She was included in the 1913
Brighton show, and exhibited with the AAA and
the London Group. Sickert selected a drawing of
hers for reproduction in the *New Age*, 12 February
1914, p.465.

The sitter told John Woodeson (Woodeson,
Spencer Gore, 1968) that she left London soon
after the beginning of the war, but a date earlier
than 1915 for this picture – with its dark line
surrounding the figure and conceptual treatment of
the features relative to known 1914 pictures –
seems impossible.

4 Shropshire 1915?
Ink and wash 11½ × 18 (29·2 × 45·7)
Signed lr: 'H. Gilman'
Exh: Lefevre, 1948 (10); Arts Council, 1954–5
(48); Reid, 1964 (63)
Lent from a Private Collection

No visit by Gilman to Shropshire is known, but as
this is stylistically a work of about 1915 it was
possibly made on Gilman's trip to see Hubert
Wellington in Staffordshire (see 55).

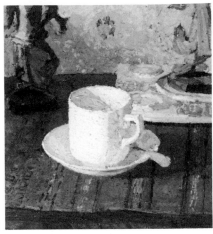

65

***65 Still Life** 1915?
Oil 11⅜ × 10⅝ (29 × 27)
Signed lr: 'H. Gilman'
Prov: Sotheby 10 June 1981
Lent by Anthony d'Offay Gallery

66 In Gloucestershire 1916
Oil 23⅜ × 18½ (59·7 × 46·3)
Signed lr: 'H. Gilman'
Exh: Lefevre, 1943 (22)
Lent by Leeds City Art Galleries

Though this probably belongs to the 1916
Gloucestershire series (see note to 71), the title,
current since the 1943 Lefevre exhibition, may not
be authentic. The canvas is probably to be
identified either with *Tree Trunk* (exh: London
Group April 1917 no.19) and the same title at the
1919 Leicester Galleries retrospective (no.12), or
with *Tree* (exh: London Group May 1918 no.56),
which may be the same as *Tree with Ivy* at the
Leicester Galleries retrospective (no.32).

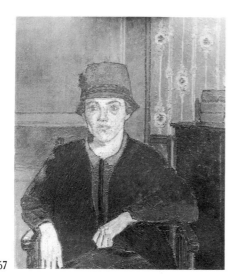

67

68

***67 Portrait of a Lady** 1915–16
Oil 24⅛ × 20¼ (61·5 × 51·5)
Unsigned
Exh: CEMA, Camden Town Group, 1944
Lit: Manchester City Art Galleries, *Concise
Catalogue of British Paintings,* II, 1978, repr. p.90
Prov: Eric Gregory; his gift to the Rutherston
Collection, Manchester City Art Galleries, 1929
Lent by City of Manchester Art Galleries

This picture is a slightly smaller version of the
painting generally known as *Miss Fletcher,* which
was shown at the 1969 Colchester retrospective
(40). There also exists an ink drawing (10 × 8¼,
sold at Sotheby's 11 December 1968), with
annotations along the bottom which identifies one
of the paintings as being the *Firelight Portrait*
exhibited at the London Group, June 1916 (73).
This identification is confirmed by a brief
description of *Firelight Portrait* by Frank Rutter in
the *Sunday Times,* 4 June 1916. On the assumption
that Gilman would not have exhibited an unsigned
painting at the London Group (see note to 63)
Firelight Portrait was probably the other version of
the composition. The identity of Miss Fletcher is
not known.

***68 Mrs Mounter at the Breakfast Table** 1916
Black ink; squared and numbered 11¼ × 7½
(28·5 × 18·9)
Signed ll: 'H. Gilman'
Exh: ? London Group, November 1916 (54);
Southampton, 1951 (37); Arts Council,1954–5
(52); Arts Council, 1961–2 (24)
Lit: Lewis and Fergusson, p.87, repr.; R. A. Bevan
1946, p.50, repr. p.49; Watney, p.127, repr. pl.11
Prov: E. McKnight Kauffer; Stanislawa de
Karlowska (Mrs Robert Bevan); R. A. Bevan gift
to the present owner 1957
Lent by the Visitors of the Ashmolean Museum,
Oxford

The first entries in any exhibition catalogue of the
Mrs Mounter set appear in the November 1916
London Group: where nos.54 and 109, both titled
Mrs Mounter were priced at £5 and £35, clearly
indicating that 54 was a drawing. R. A. Bevan
(1946) believed the drawing shown was this one.
The reproduction in Lewis and Fergusson has no
squaring but is otherwise identical, indicating
that an obsolete photograph was used. See note
to 76.

9 Mrs Mounter 1916?
Oil 13 × 17 (33·0 × 43·2)
Signed lr: 'H. Gilman'
Exh: London Group Retrospective, 1928 (66?);
Leicester Galleries, 1930 (16?); Tooth, 1934 (12);
Colchester, 1969 (38); Sheffield and Aberdeen,
'British Painting 1900–1965', 1975–6 (51); Arts
Council, 'Leeds Paintings', 1980–81 (18), repr. cat.
in colour
Lent by Leeds City Art Galleries

Probably a preliminary oil study for the larger and
more finished portraits of Gilman's landlady,
no.76 and *Mrs Mounter* 1916–17 (Walker Art
Gallery, Liverpool). The pose here is less frontal,
but the sitter's clothes and headband appear to be
the same. Though the other two versions were both
shown at the London Group, the price of £75
against the title in the 1928 London Group
Retrospective catalogue indicates that it was this
one that was shown, as that sum would then have
been very little for the larger canvases, which were
then in the collections of Hugh Blaker and Louis
Fergusson.

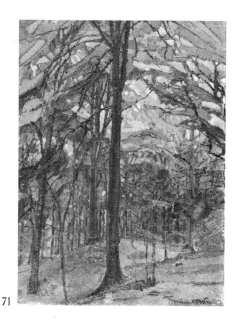

71

) Still Life 1916?
Oil 10 × 12 (25·4 × 30·5)
Signed lr: 'H. Gilman'
Exh: ? Leicester Galleries, 1919 (32 as *The
Teapot*); Arts Council, 1954–5 (35); Colchester,
1969 (39, repr.)
Prov: Earl of Sandwich; the present owner 1964
Lent from a Private Collection

Gilman seems to have painted more still lifes in
1915–6 than at any other time. This and the still
life reproduced in Lewis and Fergusson, p.77,
have the same teapot as appears in the painting of
Mrs Mounter (76).

Study in Trees, Beechwood 1916
Oil 27½ × 20 (69·5 × 51·0)
Signed lr: 'H. Gilman'. Also signed on verso
Exh: Plymouth, 1974 (10)
Prov: the artist's family
Lent by the artist's family

Hubert Wellington identified the beechwood
series as resulting from his and Gilman's stay at
The Bell at Sapperton, Gloucestershire, in the
summer of 1916. Three pictures, probably the
product of this trip, were shown at the London
Group in November 1916: *Through the Branches*
(26), *In the Woods* (37) and *Woods* (108). Five were
shown at the 1919 Leicester Galleries
retrospective: three versions of *Beechwoods* (8, 15

and 39), *A Bank of Trees* (27) and *Through Trees*
(30).
None of these titles can now be related to
specific pictures, but the pictures with which they
correspond are this one, one in the Boston Museum
of Fine Arts, one in York City Art Gallery, two
still in the artist's family and two untraced
reproductions in Lewis and Fergusson, pp.59 and
63.

72 Oak Tree 1916
Ink 16¼ × 10½ (41·3 × 26·7)
Signed lr: 'H. Gilman'
Exh: Leicester Galleries, 1919 (60?); Arts Council
1961–2 (25); Reid, 1964 (64)
Lit: *Art and Letters*, October 1917, repr.;
Rothenstein, *British Art Since 1900*, repr. pl.17
Prov: Sir Michael Sadler
Lent by John Piper

A comparable drawing is repr. Lewis and
Fergusson p.45.

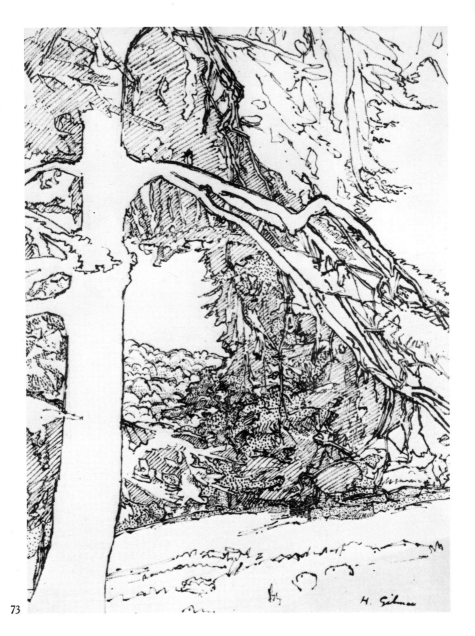

73

***73 Tree Foliage in Light and Shade** 1916
Ink over pencil 15¾ × 11 (40·0 × 28·0)
Signed lr: H. Gilman'
Prov: the present owner from the Reid Gallery,
1961 (Bevan Fund)
Lent by the Visitors of the Ashmolean Museum,
Oxford

Probably connected with the 1916 beechwood
series; the areas of flat, outline drawing, which a
a development from *The Lane* of 1915 (no.55), a
closest to the beechwood picture in the Boston
Museum of Fine Arts.

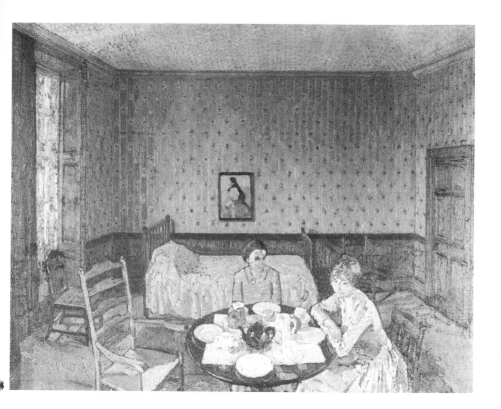

4 Tea in the Bedsitter 1916
Oil $27\frac{3}{4} \times 35\frac{3}{4}$ (71·0 × 91·5)
Signed lr: 'H. Gilman'
Exh: London Group, June 1916 (72 as *Interior*);
?AAA July 1917 (164); London Group, November
1917 (53 as *Interior*); Arts Council, 1965 (42 repr.);
Colchester, 1969 (42)
Lit: Rutter, *Sunday Times*, 4 June 1916; *Morning
Post*, 3 November 1917; Rutter, *Sunday Times*, 11
November 1917; Wilenski, *Athenaeum*, 10
October 1919; Lewis and Fergusson, p.29,
repr. p.61; Baron 1979, p.266; Watney p.128, repr.
pl.117
Prov: Lady Alice Shaw-Stewart; Lady Howick of
Glendale; Huddersfield Art Gallery from the
Leicester Galleries, 1965
Lent by Kirklees Metropolitan Council

Two identical versions of the picture exist, the
other being with the artist's family. The descriptive
title by which the picture is known is not authentic
and is of a type never used by Gilman, who
preferred such titles for his canvases as *Portrait,
Still Life*, and *Interior*, which is the proper title of
this and several other paintings of his last years.

The painting can be certainly identified from
contemporary descriptions in newspapers as the
one shown at the London Group in the summer of
1916 and autumn of 1917. The picture shown at
the AAA in 1917 (164), entitled *Interior*, was
unusually expensive, 35 guineas in contrast to
another *Interior* at £10. At the November 1917
London Group it was priced at £40 against £20
for another *Interior*. *Tea in the Bedsitter*, set in
47 Maple Street (see also nos.54, 75), depicts
Sylvia Hardy on the right, and an unknown
woman. The psychological disjunction of two
seated figures suggests a relationship with
Toulouse-Lautrec's *A la Mie* (1891; Boston,
Museum of Fine Arts). Gilman had a reproduction
of this painting in his studio in 1916 (M. Lilly,
Sickert, 1971, p.130).

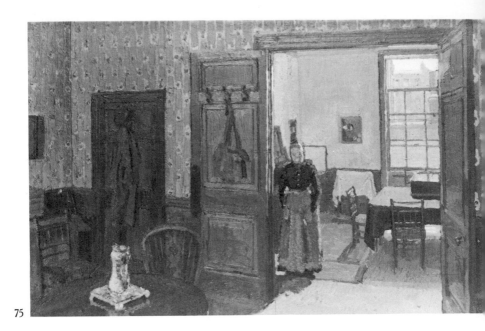

75

***75 Interior with Mrs Mounter** 1916–17
Oil 20×30 (50·8×76·2)
Exh: possibly AAA, July 1917 (164 as *Interior*, if
this was not no.74); CEMA, 1944 (11); Arts
Council, 1953 (25); Arts Council, 1954–5 (32
repr.); Royal Academy, 1963 (137); Hampstead
Festival, 1965 (17); Colchester, 1969 (41 repr.);
Mellon Centre 1980 (40 rep.)
Lit: F. Duveen, *Thirty Years of British Art*, 1930,
repr.; Wood Palmer, *Studio*, 1955, repr.; Fairfax
Hall, 1965, repr.; Baron and Cormack, Yale 1980
p.28; *Summary Catalogue of Paintings in the
Ashmolean Museum*, Oxford, 1980, p.39
Prov: Hugh Blaker; Edward Le Bas RA; gift to the
present owner from B. Fairfax Hall in memory of
Edward Le Bas RA
Lent by the Visitors of the Ashmolean Museum,
Oxford

There is another picture of approximately the
same date and also painted at Maple Street known
as *Interior (Mrs Mounter)*, formerly in the
collection of Louis Fergusson and repr. Lewis and
Fergusson p.93. Mrs Mounter is seen from the
back in the further of the rooms seen in this
picture.

76 Mrs Mounter at the Breakfast Table 1916–17
Oil 24× 16 (61× 40·5)
Signed lr: 'H. Gilman'

Exh: ? London Group, November 1916 (109);
? London Group, April 1917 (41); ? London
Group, April 1919 (unnumbered); Leicester
Galleries, 1919 (9 or 21); ? Leicester Galleries,
1930 (16); London Group Jubilee Exhibition 196
(16)
Lit: Rutter, *Sunday Times*, 19 November 1916;
Daily Telegraph, 29 November 1916; *Athenaeum*
December 1916; Rutter, *Sunday Times*, 29 April
1917; Clive Bell, *Athenaeum*, 29 April 1919;
Lewis and Fergusson pp.26–30, 31; Rutter 1922
p.135; Rothenstein 1952 p.154; Wood Palmer
1954–5 p.5; Watney pp.129, 131 n.15, 147
Prov: Hugh Blaker; Jenny Blaker; the present
owner from Jenny Blaker through the Leicester
Galleries 1942
Lent by the Trustees of the Tate Gallery, Londc

There are five oil paintings of, or including, Mrs
Mounter, Gilman's landlady at 47 Maple Street :
nos.69, 75 and 76 here, *Mrs Mounter* 1916–17 at
the Walker Art Gallery, Liverpool, and the
Interior (Mrs Mounter) referred to in the note to
75. The four known drawings of her are 52, 68, a
90 here, and a sketch (1916; Walker Art Gallery,
Liverpool), probably from life with colour notes
relating no.76 and *Mrs Mounter* 1916–1917. It is
clear (see note to no.68) that either *Mrs Mounter*
1916–17 or no.76 was shown at the London Gro
in the autumn of 1916, and the other one in the

80

spring of 1917. Sylvia Gilman told the compilers of the Tate Catalogue that the Walker Art Gallery painting and drawing, which both lack the chair present in nos.68 and 76, were made first.

The Artist's Father Reading in Bed 1917?
Ink 11¼ × 8¾ (28·6 × 22·2)
Signed and inscribed with title on the reverse
Prov: with Agnew 1965; Jane Hamilton
Lent from a Private Collection

Close in style to the series of the artist's mother in bed (see nos.78–81), which have always been dated 1917. But Gilman's father died in February that year, so this probably precedes the drawings of Gilman's mother. Gilman painted and drew his father much less than his mother. One very early oil portrait of his father is still in the Gilman family's collection, and a small drawing, ink and sepia wash (8¼ × 5¼), was dated 1916 when shown at the 1954–5 retrospective (53) and again at the Reid Gallery in 1964 (71).

81

The Artist's Mother in Bed 1917?
Ink over slight red chalk 11¼ × 9 (28·9 × 22·9)
Signed lr: 'H. Gilman'
Exh: Arts Council, 1961–2 (28 repr.)
Lit: (refers also to nos.79–81) R. A. Bevan 1946, no.83 repr.; Lewis and Fergusson, repr. p.39
Prov: R. A. Bevan; his gift to the present owner, 1957
Lent by the Visitors of the Ashmolean Museum, Oxford

Eight drawings, all of this period, can be identified of the artist's mother in bed, of which four are exhibited here (nos.78–81). The others can be traced as follows: repr. Lewis and Fergusson p.41; repr. *Studio*, June 1955 and B. Fairfax Hall 1965; repr. the catalogue 'French and English Drawings 1800–1965', Agnew 1965; The British Council.
 Ginner stressed in his writings on Gilman that Gilman was not interested in drawing as an activity independent of painting, and R. A. Bevan (1946) believes that an oil painting relating to these drawings was intended, though none is known to exist. These and the Seascapes (see nos.83–85) are the two major series of drawings in Gilman's oeuvre that have no related oil painting, and it is possible that his commission from the Canadian War Records (see nos.96–105) interrupted his painting programme to which he had not returned by the time of his death. On the other hand the reed pen drawing style he developed from c.1915 gave rise to drawings that are singularly complete in themselves and are certainly not sketches.

79 The Artist's Mother in Bed 1917?
Ink 5½ × 9¾ (13·8 × 24·4)
Signed lr: 'H. Gilman', and inscribed 'to Bevan from Gilman' on the original mount
Exh: Arts Council, 1961–2 (29); Ware Gallery, 1967 (57); Colchester, 1975 (67)
Lit: Bevan, 1946, repr. p.50
Prov: Robert Bevan, gift of the artist; R. A. Bevan, his son
Lent from a Private Collection

For nos.79, 80 and 81 see note to 78.

80 The Artist's Mother in Bed 1917?
Ink 11½ × 9¼ (29·2 × 23·5)
Signed lr: 'H. Gilman'
Exh: Newcastle, 1974 (18); Arts Council, 1980–81 (31 repr.)
Lent by the University of Newcastle upon Tyne

*81 The Artist's Mother Writing in Bed 1917?
Ink 10¼ × 6¼ (25·6 × 15·6)
Signed lr: 'H. Gilman'
Exh: Lefevre, 1948 (20); Arts Council, 1980–1 (30 repr.)
Prov: Friends of the Fitzwilliam Museum from Lefevre, 1948
Lit: Lewis and Fergusson, p.39 repr.
Lent by the Fitzwilliam Museum, Cambridge

82

***82 The Artist's Wife Sewing** 1917
Black chalk 10⅜ × 8⅛ (26·4 × 20·7)
Stamped signature on the reverse
Exh: ? Leicester Galleries, 1919 (58 as *Darning
Stockings*); ? Lefevre, 1943 (29 as *Sewing*);
? Lefevre, 1948 (8 as *Girl Darning*);
? Southampton, 1951 (36); Reid, 1964 (80);
Agnew, *English Watercolours and Drawings from
Manchester City Art Gallery*, Oct 1977 (35)

Lit: *Manchester City Art Gallery Report 1962–64*
repr. pl.X; Wood Palmer 1964, repr. as *Girl
Sewing*
Prov: the present owner from the Reid Gallery
1964.
Lent by City of Manchester Art Galleries

A study for the artist's wife in no.87.

Seascape 1917
Ink and watercolour 11 × 17 (28·0 × 43·0)
Signed lr: 'H. Gilman'
Exh: Lefevre, 1948 (15 or 16); V&A, *Modern British Watercolours*, 1975 (5)
Prov: the present owner 1962
Lent by the Victoria and Albert Museum, London

Five of these seascape drawings are known to exist: apart from the three shown here nos.83–85) there is *Seascape* I, ink and watercolour, 10½ × 16, exh: Reid 1964 (85), and *Seascape*, ink 10¼ × 16⅛, which was shown at the 1954–5 Gilman retrospective (55), at Reid 1964 (84) and by Agnew's in 1965; it was reproduced in *Alphabet and Image*, December 1946 and the *Burlington Magazine*, June 1955, p.189. Two of these five were shown at the Leicester Galleries, 1919 (42, 61).
 The seascapes relate in composition to the Romney Marsh paintings such as no.23 here and it is very likely that they show the coast in the Romney Marsh area. No Romney Marsh paintings as late as this are known, and no seascapes in oil at all.

84 Seascape II 1917
Ink and watercolour 11¼ × 17 (28·5 × 43·0)
Signed lr: 'H. Gilman'
Exh: probably Lefevre, 1948 (15 or 16); Reid, 1964 (86).
Prov: Agnew 1965
Lent by the Victoria and Albert Museum, London

See note to 83.

***85 Seascape. Breaking Waves** 1917
Ink 11¾ × 17 (29·8 × 43·1)
Signed lr: 'H. Gilman'
Exh: Arts Council, 1961–2 (27)
Lit: Lewis and Fergusson, repr. p.51 as *Small Waves*; Bevan, 1946, repr. p.59; Watney pp.127–8, repr. pl.116
Prov: the artist's family; the present owner 1957
Lent by the Visitors of the Ashmolean Museum, Oxford

See note to 83.

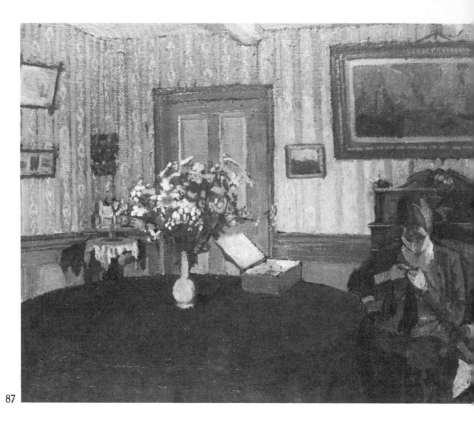

87

86 Somerset Landscape. Evening 1917
Oil 20 × 30 (50·8 × 76·2)
Signed lr: 'Gilman'
Exh: London Group Retrospective, 1928 (67);
Lefevre, 1943 (28 as *Evening Somerset*); Reid, 1964
(33); Ware Gallery, 1967 (45); Plymouth, 1974
(11)
Lit: Wood Palmer 1954–5, p.5
Prov: the artist's family
Lent by the artist's family

The date of 1917, given by Sylvia Gilman the
artist's widow for the 1954–5 retrospective,
suggests that this, like no.87, may have been done
on their honeymoon. Two drawings are known
that are stylistically of this date and have Somerset
titles: *Landscape near Wells* (Fitzwilliam Museum,
Cambridge) and *Somerset Landscape* (Art Gallery
of South Australia). Neither relates directly to 86,
but both are views in fields towards woods and
were probably made in the same neighbourhood.
One other Somerset oil painting is known,
Branches in Leaf, Somerset, Christie's, 17 June
1977, lot 68.

***87 Sylvia Darning in an Interior** 1917
Oil 16¼ × 18¼ (41·3 × 46·4)
Signed ll: 'H. Gilman'
Inscr. on the stretcher (not in the artist's hand):
'Harold Gilman/Portrait of his Wife/Interior at
Wells/given to ARH by HG'
Exh: Leicester Galleries, *Artists of Fame and
Promise*, I, July 1953, (59)
Prov: Mrs A. R. Hardy; Lefevre Gallery 1953;
J. W. Freshfield
Lent by Thos. Agnew and Sons Ltd

Gilman was married for the second time in the la
summer of 1917 to Sylvia Hardy, an artist who h
studied with him and whom he had known since
1914. The picture was painted on their honeymo
(see also note to 86), and given to Sylvia's mother
No.82 is a study for it.

84

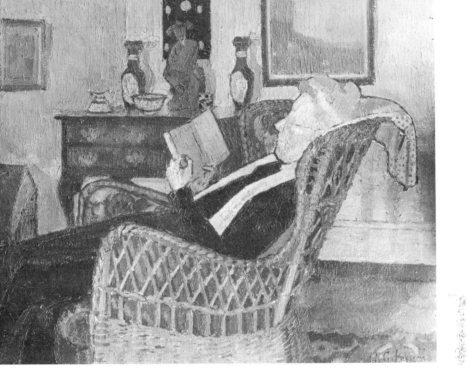

8 Interior with the Artist's Mother 1917–18
Oil 20 × 24 (51·2 × 61·4)
Signed lr: 'H. Gilman'
Exh: Tate Gallery, *CAS Fiftieth Anniversary
Exhibition*, 1960 (22)
Lit: Lewis and Fergusson, p.89, repr; John
Russell, *From Sickert to 1948*, 1948, p.15 repr.
pl.6; *Concise Catalogue of British Paintings in
Manchester City Art Gallery*, p.90, repr.
Prov: Sir Muirhead Bone for the CAS, 1921; CAS
to the present owner, 1931
Lent by the City of Manchester Art Galleries

Gilman painted two major late portraits of his
mother, this one and a full-face half-length
portrait possibly in the same chair; the latter, dated
1919 in the catalogue of the 1954–5 retrospective,
is still in the artist's family, and a squared ink
drawing for it is in the Victoria and Albert
Museum. The two could be *The Artist's Mother*
entries, nos 19 and 25 in the 1919 Leicester
Galleries show, but they are not known to have
been exhibited in the artist's lifetime.

†89 London Street Scene in Snow 1917–18
Oil 19½ × 15¼ (49·5 × 38·7)
Signed ll: 'H. Gilman'
Exh: Arts Council, 1954–5 (36 repr.)
Lit: Wood Palmer, *Studio*, 1955, repr.
Prov: Elizabeth Arnold
Lent from a Private Collection

This is the only outdoor London scene known to
the authors later than the small group of around
1911–12 which includes no.31. Gilman showed an
untraced painting called *Southampton Street, W*
with the London Group in April 1917, but this is
not of Southampton Street, and both its colour and
tight brushwork, as well as the fact that it is a
winter picture, make late 1917 the earliest possible
date.

85

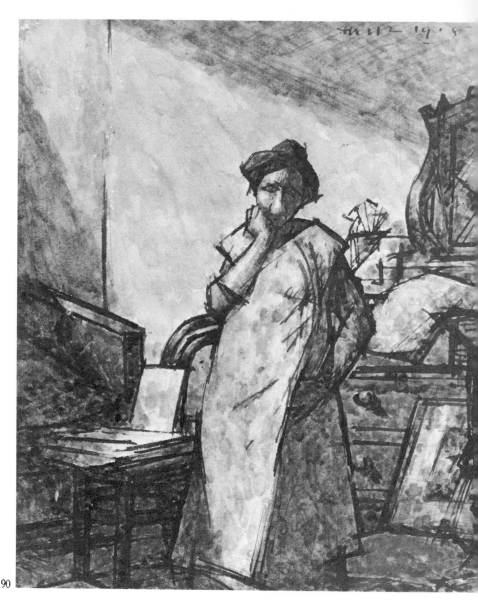

90

***90 Mrs Mounter** 1918
 Ink and watercolour $9 \times 7\frac{1}{2}$ $(22 \cdot 9 \times 19 \cdot 1)$
 Signed and dated top r: 'HG 1 12 1918'
 Lit: Watney repr. pl.119
 Prov: the present owner 1964 (Bevan Fund)
 Lent by the Visitors of the Ashmolean Museum,
 Oxford

See note to 76

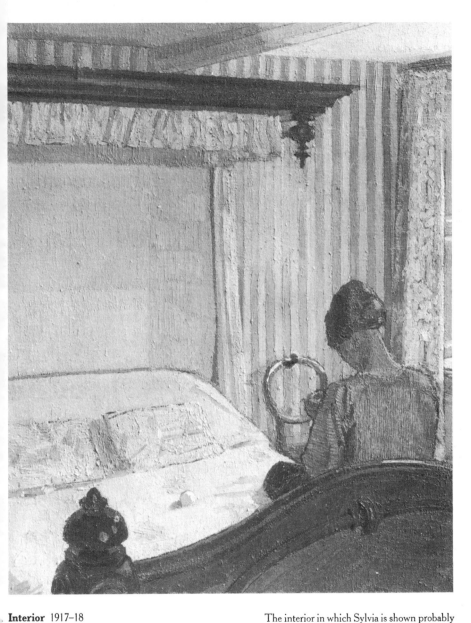

Interior 1917–18
Oil 23½ × 17½ (59·7 × 44·5)
Signed lr: 'Gilman'
Exh: Arts Council, 1954–5 (36); Colchester, 1969
(43)
Lit: Lewis and Fergusson, frontispiece, repr.;
F. Rutter, *Studio*, March 1931, p.203, repr.
Prov: Arthur Tooth; to the present owner, 1949
Lent by The British Council

The interior in which Sylvia is shown probably
represents a room at 53 Parliament Hill Fields.
The rather severe surface and taut patterning of
Interior is similar to Gilman's other late painting of
an intimate subject, the *Mother and Child* (see
under 94). In both canvases Sylvia appears to be
wearing the same blouse and the paintings must be
close in date.

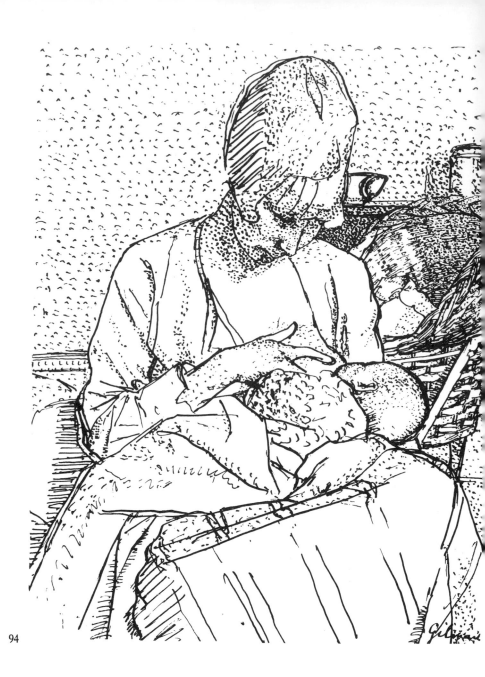

94

92 Mother and Child 1917–18
Pen and ink 10⅜ × 10⅜ (26·2 × 26·2)
Stamped signature lr
Exh: Leicester Galleries, 1919?, drawings nos.43,
53, 54 entitled *Mother and Child*
Prov: Sylvia Gilman
Lent by the artist's family

93 Mother and Child 1917–18
Pen and ink 10¼ × 8 (26 × 20·3)
Unsigned. Inscribed on verso: 'Artist's wife Sylvia
with son John H. Gilman'
Exh: see no.92
Lent by the University of Leeds

94 Mother and Child 1917–18
Pen and ink, with red chalk 11½ × 9 (29·2 × 22·8)
Signed lr: 'Gilman'
Exh: see no.92; Arts Council, 1961–2 (32); Ware
Gallery 1967 (35); Colchester, 1975 (71);
Sudbury, 1978 (35, repr.)
Lit: Lewis and Fergusson, repr. p.53; Bevan, 1946,
repr. p.58
Prov: F. S. Unwin
Lent from a Private Collection

All these drawings depict Gilman's wife Sylvia and
their baby son John. Nos.92 and 93 are rapid
preliminary investigations of the mother-and-child
motif. Gilman's natural fascination with this
subject culminated in a painting, probably
executed early in 1918 (Auckland City Art
Gallery, New Zealand; repr. Lewis and Fergusson,
p.75. The painting was no.54 at the 8th London
Group exhibition, May 1918). No.94 is identical to
the canvas in almost every respect, although the
final study for the *Mother and Child* painting would
seem to be a squared and annotated drawing also
in Auckland. However, the Auckland sheet
includes a patterned background and other details
not to be found in the more simplified painting. It
may be that the Auckland drawing was the actual
'cartoon' used during the execution of the
painting and no.94 a parallel drawing made to
investigate greater simplification. Alternatively,
no.94 could have been made after the completion
of the canvas.

95 Mother and Child with Cup 1918
Pen and ink 11⅝ × 9½ (29·5 × 24)
Stamped signature lr
Exh: see 94
Prov: Sylvia Gilman
Lent by the artist's family

The activity shown in this drawing and the slightly
advanced age of the baby serve to dissociate it from
the studies made directly for the Auckland *Mother
and Child* painting.

The Halifax Harbour Commission

With a number of other British artists Gilman was commissioned to produce a large canvas for the Canadian War Records; the painting, known as *Halifax Harbour at Sunset, 1918* is now in the National Gallery of Canada, Ottawa (77 × 132 ins; see R. F. Wodehouse, *A Checklist of the War Collections of World War I*, . . . , Ottawa 1968, p.28). In 1918 he visited Halifax, on the coast of Nova Scotia, to gather material. Details of the commission are scant; no exact dates for Gilman's visit are known and no evidence of the terms arranged between the artist and the Canadian War Records survive. Even the subject of the commission appears to be undocumented. His friend Louis Fergusson wrote that Gilman was to 'paint an enormous canvas to commemorate the scene of the great explosion' (Lewis and Fergusson, p.31), referring to the catastrophe on 6 December 1917 when the French munitions ship *Mont Blanc* blew up in the harbour with a cargo of 2300 tons of picric acid, 10 tons of guncotton and 200 tons of TNT, killing hundreds outright, devastating the district of Richmond and damaging the Halifax waterfront (T. H. Raddall, *Halifax. Warden of the North*, Toronto/Montreal, 1971, pp.250–1. See also Col. G. W. L. Nicholson, *Canadian Expeditionary Force, 1914–1919*, Ottawa, 1962, pp.345–6). However, the painting does not show the destruction of the explosion. In fact, Gilman chose to paint from the ravaged Richmond side of the bay, looking south-west towards the sunset and the less damaged Halifax. Gilman made a considerable number of drawings on his trip to Canada – almost a quarter of the drawings at the 1919 Memorial Exhibition were of Halifax – and the following selection is intended as a cross-section of the preparatory works for the commission.

96 A Ship at Sea 1918
Pen and ink over pencil 8 × 10 (20·3 × 25·3)
Stamped signature lr
Exh: Leicester Galleries, 1919 (47, 55? both *A Ship at Sea*)
Prov: Sylvia Gilman
Lent by the artist's family

Perhaps this drawing was made on one of Gilman's voyages across the Atlantic in 1918.

97 Halifax, Nova Scotia 1918
Pen and ink 10½ × 15½ (26·7 × 39·5)
Signed lr: 'Gilman'
Exh: Arts Council, 1961–2 (30); Royal Academy, 1963 (217)
Lit: Lewis and Fergusson, p.55 (repr.); F. Rutter, *Studio*, March 1931, p.204 (repr.); Bevan, 1946, p.53 (repr.); Fairfax Hall, 1965, pl.13
Prov: Sylvia Gilman; Edward Le Bas
Lent by Richard Burrows

Gilman made a number of studies, perhaps on arrival, of Halifax and its buildings. A particularly fine study of the local architecture is entitled *House at Halifax* (Bedford, Cecil Higgins Art Gallery).

98 Halifax Harbour 1918
Pen and ink 16 × 20 (40·5 × 52)
Unsigned
Exh: Lefevre, 1948 (22?); British Council, *British Watercolours and Drawings, 1900–1950*, 1980–1 (15)
Prov: Lefevre Gallery to the present owner, 1948
Lent by The British Council

***99 Halifax Harbour** 1918
Watercolour, pen and ink 14 × 21¾ (35·6 × 55·3)
Signed lr: 'H. Gilman'
Lit: *Beaverbrook Art Gallery: Paintings*, Fredericton, 1959, p.44
Prov: the artist's family; Lefevre Gallery; Lord Beaverbrook
Lent by the Beaverbrook Art Gallery, Fredericton

100 Sailing Ships, Halifax Harbour 1918
Pencil, pen and ink 16⅛ × 20⅝ (41 × 53·3)
Stamped signature lr. Inscribed (in artist's brother's hand?) lr: 'Halifax Harbour. R.H. Third and Beyond'
Prov: Sylvia Gilman
Lent by the artist's family

Nos.98–100 are all views of the harbour and its shipping, none of which relate directly to the final painting. Gilman was evidently scouting for a suitable motif.

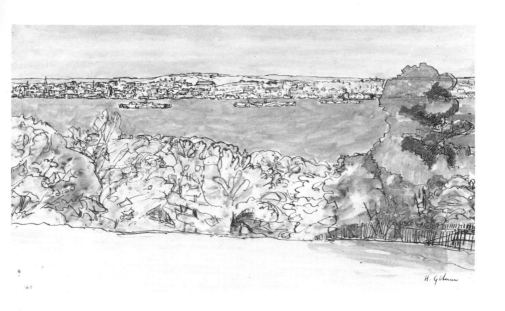

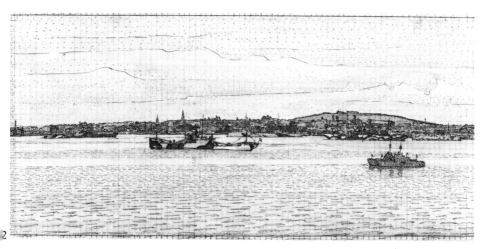

Halifax Harbour 1918
Pencil, pen and ink 12¼ × 4¾ (30·9 × 11·8)
Unsigned
Prov: artist's family; purchased by the present
owner, 1965
Lent by the National Gallery of Canada, Ottawa

***102 Halifax Harbour** 1918
Watercolour, pen and ink; squared 10 × 21⅜
(25·2 × 54·3)
Unsigned
Prov: Sylvia Gilman, her gift to the present owner,
1931
Lent by Vancouver Art Gallery

Although this large and highly finished sheet does
not correspond to the completed commission, the
detail and squaring suggest that Gilman made a
painting of this motif, or at least intended to do so.

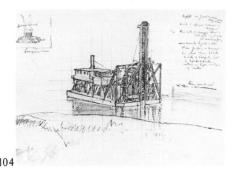

104

103 Three Ships, Halifax Harbour 1918
Watercolour, pen and ink 10⅝ × 15½ (27 × 39)
Stamped signature lr. Inscribed (in artist's
brother's hand?) ul: 'Ship 2nd. Centre/Right' and
lr: 'Halifax H. Ship Centre Right'
Exh: Lefevre, 1948 (25?); Reid, 1964 (87)
Prov: Sylvia Gilman
Lent by the artist's family

The vessel in the centre of this drawing also
appears in no.102 and, facing in the opposite
direction, in the middle of the final painting.

***104 Study for Halifax Harbour. Dredger with
Derrick** 1918
Watercolour, pencil pen and ink; squared and
annotated 7¾ × 10¼ (19·5 × 26)
Stamped signature under mount
Exh: Reid, 1964 (88)
Prov: the artist's family
Lent from a Private Collection

Once Gilman had decided on his motif he made
extensive colour notes of individual sections, no
doubt to refresh his memory when he came to
tackle the main canvas back in Britain.

***105 Study for Halifax Harbour** 1918
Oil 23¼ × 56⅞ (58·9 × 144·5)
Signed lr: 'H. Gilman'. Signed vertically in ink on
verso, lr: 'H. Gilman'
Exh; Leicester Galleries, 1919 (23); London
Public Library and Art Museum, *British Painting
in the Twentieth Century*, March 1960 (5)
Lit: F. Rutter, *Studio*, March 1931, p.206 (repr.);
Vanguard, April 1979, p.10 (repr.)
Prov: Sylvia Gilman; purchased by the present
owner, 1931
Lent by Vancouver Art Gallery

This is the large-scale preparatory canvas for the
Halifax Harbour picture. The motif established
here remained intact, with minor changes (most
notably to the rear left), in the final painting. The
completed commission was executed in London at
53 Parliament Hill Fields and was shown,
unfinished in certain parts of the sky, at the
Canadian War Memorials Exhibition, held at the
Royal Academy, January–February, 1919.

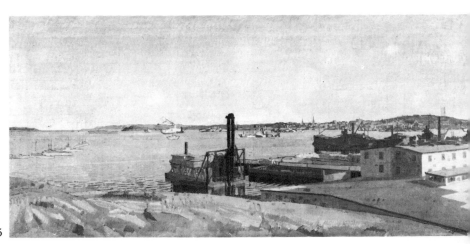

105

WALTER SICKERT (1860–1942)
Mr Gilman Speaks 1912
Pen and ink 12× 7¾ (30·5× 19·7)
Signed and dated lr: 'Sickert 1912' and inscribed
centre below: 'Mr. Gilman Speaks'
Exh: Obach's Gallery, *Society of Twelve*, 1912
(106); Arts Council, *Sickert*, 1964 (52); Perth, Art
Gallery of Western Australia, *The Drawings of
Walter Richard Sickert*, 1979 (50, repr.); Mellon
Centre, 1980 (84, repr.)
Lit: L. Browse, *Sickert*, 1960, p.103; R. Pickvance,
Sickert, 1967, Fig.1; W. Baron, *Sickert*, 1973,
pp.122–3, 125, 130, 182, 361–2, cat.330, Fig.232;
Watney, p.58, repr. p.51
Prov: Sylvia Gosse
Lent by the Victoria and Albert Museum, London

Gilman's great commitment to painting had its
ponderous and pedantic side, at which Sickert
poked fun in this drawing. Wyndham Lewis
recalled that Gilman 'was proud of a pompous
drollery, which he flavoured with every resource of
an abundantly nourished country rectory, as he
was proud of his parsonic stock. He was proud of
his reverberating pulpit voice. . .' (Lewis and
Fergusson, p.13). *Mr. Gilman Speaks* should
perhaps be informally paired with Sickert's
Vision, Volumes and Recession (*c*.1911; Islington
Libraries), a caricature of Roger Fry. The Tate
Gallery owns a painted portrait of Gilman by
Sickert (*c*.1912).

JOHN NASH (1893–1977)
Caricature of Harold Gilman 1918
Pencil 6¾× 4⅛ (17× 10·3)
Unsigned
Prov: Sylvia Gilman
Lent by the artist's family

John Nash, who became involved with the
Cumberland Market Group *c*.1915, was one of the
young painters – Keith Baynes was another –
encouraged by Gilman in the later 1910s. The
caricature shows Nash writing out a cheque for £5
to clear a debt to Gilman.

ex cat.
Mrs Mounter 1916
Ink and pencil, colour notes below 11½ × 9⅛
(29·1 × 23·3)
Signed lr: 'H. Gilman
Exh: Leicester Galleries, 1948 (13)
Lit: R. A. Bevan 1946, repr. p.54
Prov: Louis Fergusson; the present owner from
the Leicester Galleries, 1949
Lent by the Walker Art Gallery, Liverpool

BIBLIOGRAPHY

AGNEW Julian, intro to Harold Gilman
1876–1919. An English Post-Impressionist.
Colchester, Oxford, Sheffield, 1969.
BARON Wendy, *Sickert*. London, 1973.
BARON Wendy, *Miss Ethel Sands and her Circle*.
London, 1977.
BARON Wendy, *The Camden Town Group*.
London, 1979.
BARON W. and CORMACK M. intros to *The
Camden Town Group*. Yale, 1980.
BAYES Walter, 'The Camden Town Group',
Saturday Review, 25 January 1930.
BELL Clive, 'Harold Gilman', *Athenaeum*, 25
April 1919.
BELL Quentin, 'The Camden Town Group. . . .'
Motif, 10 and 11, 1962–3 and 1963–4.
BEVAN R. A., 'The Pen Drawings of Harold
Gilman', *Alphabet and Image*, December 1946.
CHAMOT Mary, *Modern Painting in England*,
London, 1937.
COOPER Douglas, 'Harold Gilman 1876–1919',
The Listener, 30 September 1943.
COOPER Douglas, *The Courtauld Collection. A
Catalogue and Introduction*. Cambridge, 1954.
EASTON Malcolm, *Art in Britain 1890–1940 . . .
from the Collection of the University of Hull*.
London, 1967.
FARR, Dennis, 'Harold Gilman 1876–1919',
Burlington Magazine, June 1955.
FARR Dennis, *English Art 1970–1940*. Oxford,
1978.
FERGUSSON Louis, 'Souvenir of Camden
Town. A Commemorative Exhibition', *Studio*,
February 1930.
FORGE Andrew (ed.), *The Townsend Journals. An
Artist's Record of His Times*. London, 1976.
GILMAN Harold, 'The Venus of Velasquez', *Art
News*, 28 April 1910.
GILMAN Harold, 'Composition in Painting', *Art
News*, 25 May 1910.
GILMAN Harold, letter to the *New Age* (referring
to Roger Fry as painter and critic), 29 January
1914.
GILMAN, Harold, interview with the *Standard*,
3 February 1914.
GILMAN Harold, 'The Worst Critic in London'
(letter), *New Age*, 11 June 1914.
GILMAN Harold, 'Sickert and Neo-Realism'
(letter), *New Age*, 25 June 1914.
GINNER Charles, 'Modern Painting and
Teaching', *Art and Letters*, July 1917.

GINNER Charles, 'Harold Gilman. An
Appreciation', *Art and Letters*, spring 1919 (also
used an introduction to the Memorial Exhibition
catalogue, October 1919).
GINNER Charles, intro. to the Tenth London
Group exhibition catalogue, London, April 1919.
GINNER Charles, Harold Gilman obituary,
Burlington Magazine, November 1919.
GINNER Charles, 'The Camden Town Group',
Studio, November 1945.
GREUTZNER Anna, in *Post-Impressionism*,
Royal Academy of Arts, London, 1979.
HALL B. Fairfax, *Paintings and Drawings by
Harold Gilman and Charles Ginner in the Collection
of Edward Le Bas*. London, 1965.
HARRISON Charles, 'The Origins of Modernism
in England', *Studio International*, September 197
HARRISON Charles, *English Art and Modernism*.
London, 1981.
LEWIS Wyndham and FERGUSSON Louis,
Harold Gilman. An Appreciation. London, 1919.
LILLY Marjorie, *Sickert. The Painter and his
Circle*. London, 1971.
MARRIOTT Charles, *Modern Movements in
Painting*. London, 1920.
NASH Paul (as Robert Derriman), 'The artist and
the Public. Harold Gilman and Groups', *New
Witness*, 25 April 1919.
NASH Paul, 'A Loss to English Art', *New Witness*,
14 November 1919.
NICOLSON Benedict, review of 'Camden Town
Group', Southampton 1951, *Burlington Magazine*,
September 1951.
ROTHENSTEIN Sir John, *Modern English
Painters*, vol.1. London, 1952.
RUTTER Frank, *Some Contemporary Artists*.
London, 1922.
RUTTER Frank, intro. to 'The Camden Town
Group. A Review'. Leicester Galleries, 1930.
RUTTER Frank, 'The Work of Harold Gilman
and Spencer Gore. A Definitive Survey.' *Studio*,
March 1931.
de SAUSMAREZ Maurice, 'The Camden Town
Pictures in the Leeds Collection'. *Leeds Art
Calendar*, spring 1950.
SICKERT Walter (ed. Osbert Sitwell), *A Free
House, or The Artist as Craftsman*. London, 1947.
SUTTON Denys, 'The Camden Town Group',
Country Life Annual, 1955.
*TATE Gallery, Modern British Paintings,
Drawings and Sculpture*, vol.1. London, 1964.

LIST OF LENDERS

WATNEY Simon, *English Post-Impressionism*. London, 1980.
WELLINGTON Hubert, intro. to 'Paintings by Harold Gilman'. Lefevre Gallery, London, 1943.
WESTBROOK Eric, intro. to 'The Camden Town Group'. Southampton Art Gallery, 1951.
WILENSKI R. H., 'Harold Gilman', *Athenaeum*, 10 October 1919.
WOOD PALMER J., intro. to 'Harold Gilman 1876–1919'. Arts Council. London, 1954–5.
WOOD PALMER J., 'Harold Gilman 1876–1919', *Studio*, June 1955.
WOOD PALMER J., intro. to 'Drawings of the Camden Town Group', Arts Council. London, 1961.
WOOD PALMER J., 'The Drawings of Harold Gilman', *Connoisseur*, April 1964.
WOODESON John, 'Spencer F. Gore', unpublished MA thesis, Courtauld Institute, 1968.

Aberdeen Art Gallery & Museums 4
Thos. Agnew & Sons Ltd 87
Arts Council of Great Britain 26, 28
Anthony d'Offay Gallery 65
Birmingham Museums & Art Gallery 12, 20
Bradford Art Galleries & Museums 46
The Royal Pavilion, Art Gallery & Museums, Brighton 50
The City of Bristol Museum & Art Gallery 19
The British Council 36, 91, 98
Richard Burrows 49, 97
Fitzwilliam Museum, Cambridge 15, 81
National Museum of Wales, Cardiff 9
Royal Albert Memorial Museum, Exeter 27
Beaverbrook Art Gallery, Fredericton 40, 99
Mrs Guy Hannen 11
Ferens Art Gallery, City of Kingston upon Hull 31
Johannesburg Art Gallery 35
Mr & Mrs Evelyn Joll 30
Kirkcaldy Art Gallery 10
Kirklees Metropolitan Council 74
Leeds City Art Galleries 6, 7, 16, 29, 66, 69
University of Leeds 93
Leicestershire Museum & Art Gallery 18
Walker Art Gallery, Liverpool ex cat.
The Trustees of the Tate Gallery, London 41, 42, 61, 62, 76
Victoria & Albert Museum, London 14, 57, 58, 83, 84
City of Manchester Art Galleries 67, 82, 88
Whitworth Art Gallery, University of Manchester 25
The Mayor Gallery 21
The University of Newcastle upon Tyne 33, 80
Odin's Restaurant 5
National Gallery of Canada, Ottawa 39, 101
Visitors of the Ashmolean Museum, Oxford 1 37, 68, 73, 75, 78, 85, 90,
John Piper 72
Plymouth City Museum & Art Gallery 55, 56
Southampton Art Gallery 17, 47
City Museum & Art Gallery, Stoke on Trent 22
Vancouver Art Gallery 102, 105
Vint Trust 13, 34
Wakefield Art Gallery & Museums 53
Lord & Lady Walston 8
Worthing Museum & Art Gallery 44
York City Art Gallery 24

© Arts Council of Great Britain 1981

ISBN 0 7287 0296 7

Designed by Charlton/Szyszkowski
Printed in England by Lund Humphries,
Bradford and London

Exhibition Organiser: Nicola Bennett
Exhibition Assistant: Rowena McWilliams

City Museum and Art Gallery,
Stoke-on-Trent
10 October – 14 November 1981

York City Art Gallery
25 November 1981 – 3 January 1982

Birmingham Museum and Art Gallery
14 January – 14 February 1982

Royal Academy of Arts, London
25 February – 4 April 1982

Cover: *Mrs Mounter at the Breakfast Table*
1916–17 (76)
Back: *Mrs Mounter at the Breakfast Table* 1916 (68)

Photographs supplied by lenders or as in captions
except:
Courtauld Institute of Art 48, 49
Prudence Cuming Associates Ltd 32, 63, 71
Sydney Newbery 5, 52

Please note that nos. 5, 42 and 87 will be exhibited
at the Royal Academy only; nos. 12 and 20 will not
be available for this showing.

A list of Arts Council publications
including all exhibition catalogues
in print, can be obtained from the
Publications Department
Arts Council of Great Britain
105 Piccadilly
London W1V 0AU

51-6
5-13